Graham Sutherland An Unfinished World

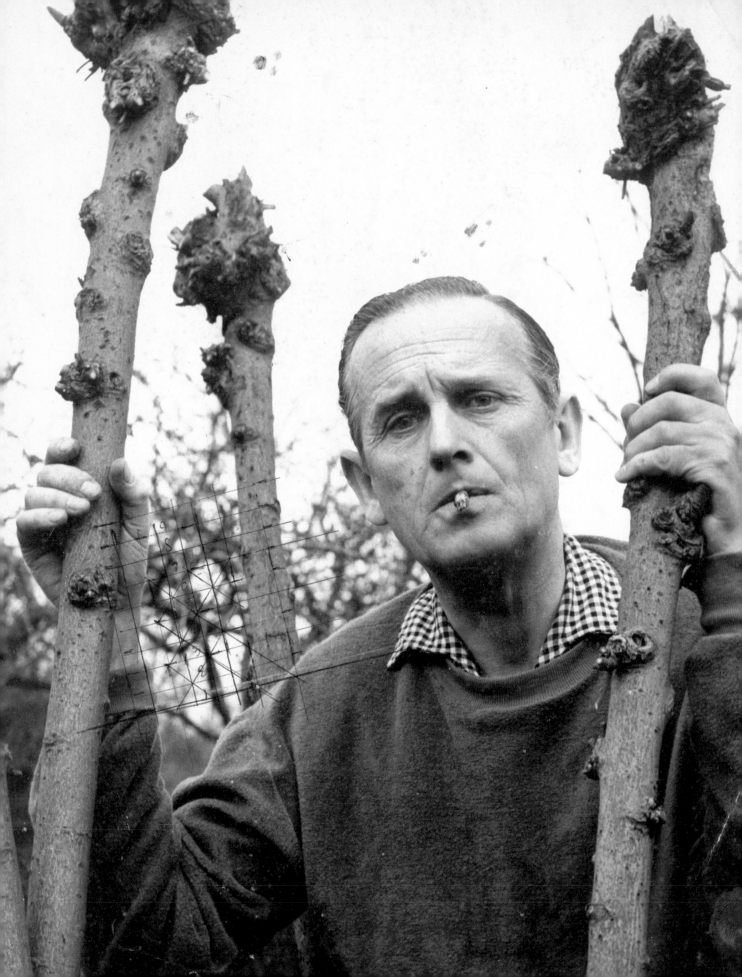

Graham Sutherland

An Unfinished World

Curated by George Shaw

MODERN ART OXFORD

5 **Introduction** Michael Stanley

7 **Graham Sutherland: An Unfinished World Works on Paper 1935–1976** George Shaw

21 **Monuments and Presences** Brian Catling

25 **Sutherland's Metamorphoses** Alexandra Harris

30 **Plates**

108 **List of Works**

110 **Biography** Rachel Flynn

112 **Acknowledgements**

Frontispiece, *Graham Sutherland*
by John Hedgecoe Photograph, c.1968.
Amgueddfa Cymru – National Museum Wales
© TopFoto

Introduction

This exhibition, curated by the artist George Shaw, brings together over eighty works on paper by the late artist Graham Sutherland. It focuses largely on the early Pembrokeshire landscapes from the 1930s and moves cyclically through the devastation of the intervening war years – of twisted girders and slate mines – and returns to the Welsh estuaries and coastlines of the early 1970s. It is the largest selection of drawings and gouaches on paper ever presented in a single exhibition and reunites passages of work that for a long time have resided in private collections, regional and national galleries and museum stores.

At his height, Graham Sutherland was the most celebrated and successful British painter of his generation, internationally renowned and enjoying a fully furnished celebrity lifestyle in continental Europe. His probing portraits of the late 1950s and 1960s of British high society: Somerset Maugham, Kenneth Clark and the famous Winston Churchill portrait, attest to the company he kept and the circles in which he moved. In addition, his robust, often garish canvases of biomorphic forms and grotesqueries reveal an incredible breadth, a breadth for instance exemplified by the physical enormity of his tapestry that adorns the altar of Coventry Cathedral and for which he is more widely known to a British public.

This exhibition however runs counter to the staggering monumentality of such works and instead celebrates monuments of an entirely different order. These are monuments located very much in the psyche of Sutherland's enduring relationship to landscape, both materially and allegorically, and often manifest in the most modest, direct and humble of drawings and works on paper. Often no bigger than a postcard or sketchbook page or a leaf of A4 paper, the bringing together of these works pays homage to Sutherland's incessant and prolific working and reworking of familiar motifs and forms, and the solace of a quieter, reflective, but no less intense passage of study.

This is not an exhibition therefore that heroically seeks to reassert the work of Graham Sutherland as an artist underrated, forgotten or having fallen out of favour – though that may be true. There are no grandiose statements or alarming new findings that will alter the canonical register, but instead we present an exhibition that embraces and revels in the minutiae of an artist's singular obsession: that gives visibility to the dilemma of making a mark on paper, of ultimately what it means to commit to and to celebrate a life's project, however modest or unacknowledged.

With this, it is fitting that the exhibition has been conceived and presented through a contemporary lens and specifically through the vision and sentiment of the celebrated artist George Shaw. Engaged wholeheartedly in his very own life project: the ceaseless chronicling of Tile Hill estate in Coventry where he was born and raised, the presence of Sutherland's tapestry casting a vestigial shadow over Shaw's upbringing gives a compelling autobiographical charge. In addition, the exhibition asks questions about the relevance of such work to today's artists, to today's art making and to the ways in which the idea of an English sensibility navigates its relationship to the rest of the world, with all the inherent contradictions, anxieties and nagging doubts.

With all such projects we are grateful to those that helped shape, conceive and make possible this exhibition which has relied so heavily on the generous loans of works from institutions and individuals alike. We are especially grateful to those national museums and organisations including Tate, the Imperial War Museum, the British Council, Arts Council England, the V&A and National Museum Wales, that have so positively responded to our requests. The breadth of work that comes from the richness of regional museum collections is staggering and testament to the high regard in which Sutherland's work is held across the whole of the UK. In addition this exhibition is supported by generous loans from many private and individual collections, with loans from those who knew the artist personally and from those who uphold and share his remarkable influence and world view.

We are especially thankful to those who have contributed to this publication itself: the artist Brian Catling, writer and academic Alexandra Harris and the Sutherland scholar, Rachel Flynn. This exhibition would not, however, have been possible without the imagination and vision of George Shaw whom we are eternally grateful to for the passion and respect with which he has helped to curate and bring together this exhibition. Finally we would like to pay our sincere respect to the work and life of Graham Sutherland, an artist of extreme stature, whose work continues to pose as many compelling and pertinent questions today as it did when it was first conceived.

Michael Stanley
Director, Modern Art Oxford

Graham Sutherland: An Unfinished World Works on Paper 1935–1976

George Shaw

> 'Mr Sutherland's world is an unfinished thing, as though it had been abandoned halfway through the fifth day of creation. His shapes, for all their subtlety, are clumsy. They suggest dinosaurs and mammoths. His hills heave themselves grimly against the sky. They are stark uncomfortable monsters made of raw earth and rock.'[1]

> 'I've been waiting for a guide to come and take me by the hand.'[2]

The insistent worm Sutherland burrows invisibly and deeply into the mythology of my own imagination; as it is now, certainly, but more significantly and more strangely into what it was and perhaps what it promises to be. I know he didn't mean this. He never knew I existed and took his last breath roughly when I was a teenager painting in my bedroom listening to *Unknown Pleasures*[3] for the first time. But there is something about the world he shows me that I recognise not as being the world in front of me, but maybe the world behind me and maybe again the world both inside and beyond who I am and where I am.

Any interest I have in Graham Sutherland can be traced back to growing up in Coventry. The new cathedral, as it butted itself up to the ruins of the old one, was like an art gallery, and I knew from books that art connected the world in some way to God. Outside the cathedral, Jacob Epstein's St Michael stood triumphant over the well-endowed devil and inside hung Sutherland's monstrous tapestry. Despite its size I was never that interested in it, though I think of it now like a prehistoric monolith and wonderfully irrelevant – hidden from the passing world. In his essay on Sutherland, 'The Damned',[4] David Mellor invokes both the *Quatermass* films and John Wyndham's *Day of the Triffids* in his discussion of the vegetable-human hybrids of Sutherland's imagination. He leaves us with the image from *Quatermass* of the interior of Westminster Cathedral infected by the massive 'organic horror' our British hero, the astronaut Carroon has become. Though there is no indication of such organic forms in the tapestry, it is the green of it that strikes anyone looking at it: the outside inside; the green man of folklore disguised as the risen Christ. I was more fascinated by the mass of studies for it displayed in the gloomy Herbert Art Gallery & Museum opposite. I recall walking through cases of stuffed

animals and bits of antique machinery to the upper floors where the paintings were and there it seemed like I was the only person in the world who knew this place existed. Study after study showed me an artist in two minds; an artist who seemed to work in the same way as I did: rehearsing and stuttering, hesitant about whether or not to show the world what's in his head. From there and via John Piper's painting of the ruins of Coventry Cathedral, I came across Sutherland's drawings and paintings of bomb sites.

I have always been fascinated by the work artists made during times of war, particularly when what we think will never happen to us and our lives and our homes happens right here. When the end of things just happens. Sutherland was one of those artists who never left the British Isles during the Second World War, but drew a salary documenting the effects of the war at home. It's a difficult job I suppose, but someone has to do it. Something of his *Devastation* series, which I probably saw at the Imperial War Museum on trips to London with my Dad, sent me back to Coventry and to Philip Larkin's description in *Jill* of a return home from college during the war:

> As soon as he was out of their sight he broke into a quick shamble, filled with the other's words with a desire to know the worst. He ran down a side street, leaping over pools of a curious red mud compounded of brick dust and hosepipe water. It seemed utterly deserted here: here and there a house, a mere shell, would be standing, but on the whole it seemed like a city abandoned because of pestilence or a migration of humanity.[5]

John Piper, *Coventry Cathedral, 15th November 1940*, 1960
76.2 × 63.5 cm. Transferred to Manchester City Galleries by
H.M. Government War Artists' Advisory Committee 1947

Or nearly 40 years later, the year after Sutherland died:

> This town, is coming like a ghost town
> All the clubs have been closed down
> This place, is coming like a ghost town
> Bands won't play no more
> Too much fighting on the dance floor[6]

In those early days before I left home for art school, I thought of myself as an artist. One of my pursuits was to leave the house with a sketchbook and a bag of pencils and paints and spend the day exiled on the outskirts of Coventry drawing fields and trees, paths and skies. It was an excuse for being alone I suppose, but it was also the beginning of looking for something, of the attempt to find outside of yourself that thing you knew was inside yourself. When I first saw Sutherland's early Pembrokeshire landscapes, I recognised in the work a familiar ambition. He's not interested in things, certainly not in things as they are, but perhaps in what they once were and will be, of what they could be. Nothing in his landscape answers anything. Shaking and scraping the shit of British Landscape off his shoes he opens up a vision to the very questions that run the risk of closing it down; what he himself might describe as the 'precarious tension of opposites'. His suns, hills, valleys, roads, roots and skies are not our first encounter with the world around us: it is a second-hand deliverance, used up, tattered, passed on – the marks of its previous owners all too apparent. There is nothing new and nothing finished in Sutherland's world.

George Shaw, *Untitled*, 1984
Charcoal and chalk on paper

George Shaw, *Avebury*, 1992
Watercolour and ink on paper

9

In my current middle-aged state I often catch myself recalling the films, TV and music of those earlier days. What I find intriguing now is what fascinated me then. In the BBC children's series *The Changes*, seventies Britain is devastated by a force that compels the population to destroy the machines and electrical goods that they use in their daily lives. The country descends into anarchy and almost into medieval feudalism. Each episode tells the story of a teenage girl, Nicky, who begins looking for her parents but who ends up travelling west to discover the origin of this force. The concluding episodes – set amongst the rocks of a Welsh quarry, which uncover the power that holds nature and progress in balance – prefigures my interest in the concerns of the Neo-Romantic movement and Sutherland's work of the thirties and forties in particular. Similarly the ITV series *The Children of the Stones* helped me identify more than a passing concern for the British landscape and the ancient presence of man and of beliefs. Filmed at Avebury in the 1970s it tells the story of an archaeologist and his son who arrive there to conduct a survey. They quickly get caught up in the strange goings on of the place and its people, but what is most compelling is the sinister atmosphere, the sensation of a world beyond ours yet within reach and its stark contemporary setting: a kind of *Wicker Man* meets *Grange Hill.* Both programmes have lurked quietly in the shadows of my imagination biding their time. Sutherland himself wrote somewhat mysteriously in 1973, conjuring up the ghost of Arthur Machen, the Welsh author and mystic, in whose dreams and nightmares time dissolves and the ancients come calling: 'If I could barricade myself within a ring of rocks I would be pleased.'[7]

In 1942, in the art magazine *Horizon*, Sutherland published his 'Welsh Sketch Book' in an attempt to describe, in his words, 'the sort of things that starts one off.' He relates how a visit to Pembrokeshire in 1934 was the time and place in which he began to learn painting.

Children of the Stones, 1976, HTV.
Image courtesy of BFI/ITV

His arrival in that part of the country coincides with Paul Nash publishing in *Unit One* the thoughts and intentions he has for his own work; genius locii is indeed almost its conception. It is a vague and attractive text skirting the subjects of Englishness, the English landscape tradition, the Celtic, symbolism, Nature, Blake and Turner. He seems to be looking for an unapologetic and contemporary English art:

> Last summer I walked in a field near Avebury where two rough monoliths stand up, 16 feet high, miraculously patterned with black and orange lichen; these are remnants of the avenue of stones which led to the Great Circle. A mile away, a green pyramid casts a gigantic shadow. In the hedge, at hand, the white trumpet of a Convolvulus turns from its spiral stem, following the sun. In my art I would solve such an equation.[8]

It may well read as a manifesto for Sutherland. He leaves Kent as a kind of pilgrim, heading for the setting sun. After a good deal of wandering about he seems to find what he's looking for. It is well known that Sutherland was a Catholic and much has been and can be read into that. But looking at his work and what he says about it, there is little evidence that Catholicism or even Christianity was high on the list of the things he was looking for. There is none of the zeal of the convert though he is clearly in search of, or recognises the existence of, something outside of himself. We might well define this as the spiritual, but I'm not qualified to say much more than that. Roger Berthoud, in his biography of Sutherland, includes a recollection from Sutherland that he found Catholicism claustrophobic: 'I found I couldn't go to church without considerable distress – I felt I was hemmed in and couldn't get out.'[9] This echoes an earlier recollection in the same biography when Sutherland was an apprentice engineer in Derby and

got trapped in the boiler of a shunting engine: 'I think that's how claustrophobia started with me. There was time when it was aggravated by agoraphobia. For instance, to cross a street was agony. I never had agoraphobia in the country, only when there were milling crowds crossing the road or something.'[10] It feels like the thing he was looking for was a way out.

In a postcard of September 1938 to Paul Nash he wrote: 'We are in Pembrokeshire, alternating between enjoyment of this superb countryside and desolation as we scan the European horizon.'[11] Is he taking the piss? Without leaving the island he couldn't get further from the approaching Nazis! Perhaps Pembrokeshire was the step towards a more philosophical way out: the light at the end of the tunnel. I'm reminded of Graham Greene in *A Sort of Life* as he contemplates his own reasons for converting to Catholicism, 'I cannot be bothered to remember, I accept. With the approach of death I care less and less about religious truth. One hasn't long to wait for revelation or darkness.'[12] This is a hint at Sutherland's quest. Considering his own words to Berthoud shortly before he died, 'Although I am by no means devout, as many people write of me, it is almost certainly an infinitely valuable support to all my actions and thoughts. Some might call my vision pantheist. I am certainly held by the inner rhythms and order of nature; by the completeness of a master plan;'[13] it sounds most pre-Christian. Looking at a number of his drawings it is worth noting that no matter how gestural or abstract his mark-making becomes he can't quite shake off his adherence to the grid. At times the practical use of this method of transferring or enlarging drawings is obvious and at other times it appears almost decorative or fetishised. Whatever it is and however it is used, the grid unifies the separate elements of the drawing; it is something reliable and timeless, both beneath and on the surface of things. Though I don't see him quite throwing off his tweeds and cravat in exchange for a white cloak and a crown of leaves he does, at least, hold hands with a pagan view of the world. But whatever it is Sutherland wants and yearns for it and the work he makes in this part of Britain is witness to this endeavour.

> The lonely light that Samuel Palmer engraved,
> An image of mysterious wisdom won by toil;
> And now he seeks in book or manuscript
> What he shall never find.[14]

In these Welsh landscapes of the mid 1930s until just after the end of the Second World War we see a world standing with great fragility in the soil and darkness of its own making. The

creation of life lies in the same damp bed as its end. Roots tangle up with shoots. Lanes loop into each other. Horizon lines fold into foregrounds. The vertical becomes horizontal. What was solid becomes fluid. What was on the surface is buried and what was buried emerges into the air. What was in the light of the present day becomes hidden as history claims the view as though it was the weather. At the same time such a vision seems to expect the arrival of the war and these landscapes appear as prelude or prophecy. It is strange that the Pembrokeshire of Sutherland's pre-war landscapes are as apocalyptic as if they were made after the war. Figures are hard to spot, as is any sign of civilisation. These works claim the territory of Constable's beautifully incomplete studies folding into their own creation having passed slug-like through our world.

In *Pembrokeshire Landscape*, 1935, (p.31), a road recedes into the distance and shadows scrape and claw across the hilly ground in the shape of hoofs or horns. On the roadside stands silent what must be a bluestone. Its reason for being is long forgotten. Stacks of corn sit waiting. There are no happy peasants working the land. They are long gone. It is the view of an escapee, a longed-for stillness and emptiness. In Geoffrey Household's novel *Rogue Male*, our unnamed protagonist flees west from his pursuers and buries himself in the earth amongst the roots and stones. The place he locates is significant only to him; it is not marked on the map.[15] This is not cartography and neither is it an end point. As the road bends, Sutherland seems to imagine it going straight on. In a series of dotted lines the ghost of a road takes us over the fields and goes beyond the horizon line into the sky and beyond. The lines themselves are converging but their vanishing point is beyond our view. Similar lines connect a road of standing stones to the sun in *Sun Setting Between Hills*, 1937, (p.32), intersected by what looks like, from a distance, a huge arrow pointing out of the picture. In *Man and Fields*, 1944, (p.100), there are

John Constable, *Old Sarum*, c.1829, oil on thin card, 14.3 × 21 cm. Victoria and Albert Museum, London

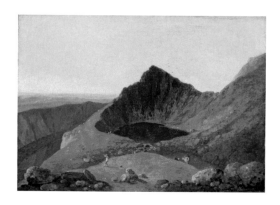

what look like wires connecting the man's head to a setting sun. It looks like he's wearing a Walkman, as if he's listening to the sun. Or the other way around of course. As I look at his work I get the impression that Sutherland is not telling me what he wants to say; he's merely pointing. The darkness of *Road Mounting Between Hedges, Sunrise*, 1949, and *Dark Hill – Landscape with Hedges and Fields*, 1940, (pp.101 & 49), evoke an alien landscape, uncharted and hostile. Shapes and shadows suggest what they are probably not, hills become stains become creeping slithering creatures, something sliding from the sea sperm-like, primeval. It is as though he's dipped his brush into the pigment pool of Richard Wilson's *Llyn-y-Cau, Cader Idris,* c.1774, dragging its hidden history across the paper. What could be a line describing a cloud, attaches itself to the top of a distant hill like a caught pubic hair. *Little Mountain in Wales*, 1944, (p.87), bursts like a blister on the horizon line and leaks down to the foreground foliage. Other mountains become breasts or nipples, while roots and branches suggest tangled arms and legs. At times his views open up and close like a human body. Such allegories and heaps of discarded humanity suggest over and over again the paintings of Philip Guston. Abstraction falls away and the figure is exposed to the elements.

Pictures such as *Rocky Landscape with Sullen Sky,* 1940 or *Study for 'Horned Forms'*, 1944, (pp.51 & 90), are less like paintings than they are warning signs to keep out: 'Turn around, there's nothing here for you.' If Sutherland is painting the future, it is a vision of Britain that *Riddley Walker*[16] passes through on his own pilgrimage for answers. It is a landscape that has absorbed time, in which individuals can become consumed, where language, civilisation and progress count for nothing. Is both past and future. A landscape of forgetting and of the forgotten.

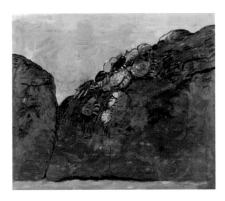

Dark nite it wer Dark of the Moon but where the woodlings littlt off to barrens I cud feal it on my face the open of it and I had the fealings insde me I never had befor. Sour groun and dead the barrens are you cudnt grow nothing on them only the dry dud blowing in the summer and the grey mud in the winter. Even the wind blowing the dus is something moving tho it aint jus only dead groun in a stilness. Seeds blow in the wind and what is earf is a deadness with life growing out of it?[17]

These Pembrokeshire years show a world dead or dying. The fields offer little fertility and the sun seems not to warm much. Towards the end of the war and his departure from this part of the world there is an interest in harvest time with his pictures of cornstooks and a yellowing sun, but for the most part Sutherland sought to grow his vision in this barren earth. A few years before his discovery of Pembrokeshire, his wife Kathleen and himself had lost their three-month-old baby son. Roger Berthoud, his biographer, finds Sutherland's dismissal of this fact hard to accept,[18] and I would agree. If we believe Francis Bacon's biographer Daniel Farson in *The Gilded Gutter Life of Francis Bacon*, Sutherland referred to the incident as 'our trouble' and Farson elaborates that their first child was not stillborn but so deformed that there was little more than a stump and a heart, no arms or legs; for a week the baby lived, and then, mercifully, died. Farson then adds that they both referred to his work, spookily enough, as 'our children'.[19] Once these tales are told it is hard not to view this period of Sutherland's work without its shadow. A landscape of forgetting.

To see a solitary human figure descending such a road at the solemn moment of sunset is to realise the enveloping quality of the earth, which can create, as it does here, a mysterious space limit – a womb-like enclosure – which gives the human form an extraordinary focus and significance.[20]

Philip Guston, *Ravine*, 1979, oil on canvas, 175.3 × 236.2 cm.
Centre Georges Pompidou © Estate of Philip Guston,
image courtesy of RNM

The bombed and damaged buildings in Sutherland's work made for the War Artists Advisory Committee are as empty as his lanes and hills. Each drawing is filled with the people who are no longer there. He is as solitary in the streets of London or Swansea as he was in the countryside, and the debris of collapsed buildings tremble with the suggestion of symbolism as though their present tense as sites of destruction and carnage were not enough. The man-made is caught in its tragic and inevitable return to its natural state: slate and brick and mortar, iron and glass and wood are being absorbed again by the earth, being un-made. Sutherland never seems that comfortable in the skin of 'official' artist, his vision is too consuming for the sights of war to steal it from him. Everything becomes absorbed by his vision and into his own portable mythology. He grasps the opportunity to see what the world is like beneath the surface: excavators move earth aside and drag and dig out the ancient minerals or fuels. Here are huge holes, inverted earthworks, lines and marks made on the landscape itself as though it too was a piece of paper. Time is accelerated by man and machine. For a claustrophobic it must have been far from bearable to descend with miners underground, so what was he after? His entrance to a lane becomes an entrance in to the earth itself. What begins as a way out becomes ways in, ways underneath and ways through. There comes a point where escape becomes a pursuit in itself.

> There come moments in all our lives, when, rending and tearing at the very roots of our existence, we seek to extricate ourselves from ourselves and to get ourselves out of the way of ourselves, as if we were seeking to make room for some deeper personality within us, which is ourselves and yet not our self. This is that impersonal element which the aesthetic sense demands in all supreme works of art so that the soul may find at once its realisation of itself and its liberation from itself.[21]

In Sutherland's world, rocks, trees, hills, roads and cornstooks, man-made cavities, collapsed roofs, broken walls and twisted girders, in short the stuff around us, combine to allude to Christian motifs of the cross, to prehistoric earthworks and pagan and Anglo Saxon fertility worship and commemoration of the dead. Whatever the exact meaning of such archaeology we are left in no doubt about its relevance to the land, the time of year, cycles of growth and decay, the resolution between the ephemeral and the eternal, the mapping of the universe above onto the ground below; the fusing of letting go with holding on. And how seamlessly in British history are such traditions entwined. Sutherland is at his strongest when he is at his

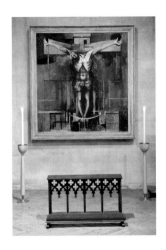 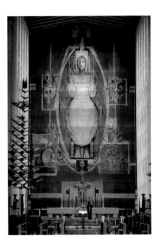

least specific; he is not an artist who convinces us of his vision by its dogma but rather by its indecision, its vagueness. At times it is as hard to tell sky from land as it is to tell field from road, or pagan from Christian, or wartime from peacetime. Are these the thorns of some May Day parade or the thorns of Christ's crown; the wood of some rotted henge or fragments of the true cross? Or perhaps they are simply thorns or trees without narrative or symbolic interpretation. Each detail reaches out beyond itself, from the confines of being branches, stones, burnt out rolls of paper or a pile of rubble to be defined as eternal substance. Sutherland becomes a prehistoric diviner in whose hands earthly objects are halfway between the world and the unknown, or the local priest who stands over the transfiguration of elements: wine into blood and bread into flesh. The everyday is sacrificed.

Sutherland's most religious works are these landscapes. His *Crucifixion,* 1946, for St Matthews Church, Northampton or his *Christ in Glory in the Tetramorph,* 1953, – the tapestry for Coventry Cathedral – are overshadowed by *Tree Forms in Estuary*, 1939, or *Fallen Lift Shaft*, 1941, or *Cornstook in Landscape,* 1945, (pp.43, 58 & 103), because their vision is gently human, made in awe; they are not illustrations but transformations, the beginning of something and not its yawning conclusion in death. His drawings of burnt-out paper rolls show them returning to their original tree trunk forms, metamorphosed by fire and water.

And funnily enough it is these rolls of paper that turn my thoughts to drawing, to working on paper. In watercolours and drawings we often see the paper itself, showing through the medium or on the uncovered edges of the image. We see the nothingness that was at the start of it all, the nothingness that will be there again without the rigours of conservation. But most

Graham Sutherland, *Crucifixion*, 1946, St Matthew's Church, Northampton

Graham Sutherland, *Christ in Glory in the Tetramorph*, 1953, Coventry Cathedral

of all these works on paper lack what I've learnt to describe as 'finish', and there hangs the magic of each work. Mediums are by their very nature the place between two worlds. They have neither beginning nor end beside that which is ascribed outside of themselves. They carry messages from one world to another. But they are fascinating and magical in their own right because they are mute and incomplete; they hold some form of secret in their silent humility. We should ask of ourselves what manner of things may be hidden in or revealed in a drawing and we find that their beauty lies in the balance between these two states. Sutherland's works on paper fascinate me in a way that his major paintings or commissions fail to do. I see in them the very indecision and urgent journeying that marks my own daily thoughts and actions both in the studio and in the world beyond. There is, in his creative imagination, the wish to transform the observed. He talks and writes frequently of equivalents and paraphrases and stand-ins. In 1972 Sutherland wrote about drawing as, 'enchanting to me and exciting. One feels one has no responsibility (as one has in painting) – or if one has, only to these so-called inanimate objects; they do not press me. There is simply the fascination of things seen, and trying to understand the principles of what one sees.'[22]

There is a certain kind of strange communication where the inanimate speaks for the individual, finds words for the inarticulate, where what we find in the outside world correlates weight for weight with what we can't quite find within ourselves. At times it is hard to tell whether the artist finds the motif or the motif finds the artist; where motif becomes motive. And at other times the act of drawing is something like a seance, where by certain actions – movements of the hand – the unseen world is brought forth: the world that we believe holds some secret, some comfort, some knowledge; a world we feel we may dissolve into at any moment. Thus the drawing becomes the residue of getting from here to there: what is left over once directions have been given and the traveller feels confident to go on.

In any case, the painter is a kind of blotting paper: he soaks up impressions. He goes through 'periods of fullness and evacuation' as Picasso has said, and is very much part of the world. The painter cannot therefore avoid soaking up the implications of the outer chaos of twentieth-century civilisation. By that token, tragic pictures will be painted – subconsciously perhaps – and without necessarily having a tragic subject. Picasso himself during the war painted tragic 'still lives'; maybe one can only 'mutter in darkness – spirit sore.' But one has in one's hand the instruments of transformation and redemption.[23]

After 15 years of Mediterranean sunshine, Sutherland returned to Pembrokeshire like some kind of prodigal shit in the shuttered chateau.[24] Pausing only to reflect on his time in the South

of France as, 'one long and regrettable gap, brought about by the fact that I thought I had exhausted what the countryside had to offer',[25] he quickly resumed the work, the search, the escape. There are photographs of him wandering the foreshore and woods, covered up in hat, cap and wellies uncovering his unfinished vision. Looking at the drawings and watercolours, notes and sketches I find it hard at times to tell the difference between the work of the 30-year-old from the work of the 70-year-old. Albert Camus wrote that a man's work is nothing but this slow trek to rediscover through the detours of art, those two or three great and simple images in whose presence his heart first opened.[26] Here we see Sutherland unable and unwilling to free himself from the roots that clutch.

In the film *The Halfway House*,[27] a collection of strangers has escaped from their war-torn lives to the Welsh countryside and the welcoming pub of their memories. But nothing is as it seems because the pub had been bombed the previous year and what looks like the landlord and his daughter are in fact ghosts, offering the possibility of redemption and rebirth from the ashes of the destroyed home. Made in the same year that T.S. Eliot published *Four Quartets*, our strange pilgrims undergo the same metamorphosis promised by each of those four poems. What seems at first like the threat of completion, the close of all visible and invisible things is in truth an offer of transformation. Unconscious of his wristwatch, Sutherland followed the setting sun and marked its vanishing into damp British earth and history.

> Through the unknown, remembered gate
> When the last of earth left to discover
> Is that which was the beginning;[28]

The Halfway House, Dir. Basil Dearden, U.K., 1944
© STUDIOCANAL

1 Eric Newton, review from October 1938 reprinted in *In My View*, Longmans, Green & Co., London, 1950

2 Joy Division, *Disorder*, 1979

3 Joy Division, *Unknown Pleasures*, 1979

4 David Mellor (ed), 'The Damned', *A Paradise Lost: The Neo-Romantic Imagination in Britain, 1935–55*, Lund Humphries / Barbican, London, 1987

5 Philip Larkin, *Jill,* Faber & Faber, London, 1946

6 *Ghost Town,* The Specials, 1981

7 Graham Sutherland, *Sutherland in Wales: A Catalogue of the Collection at the Graham Sutherland Gallery,* Picton Castle Trust, Alistair McAlpine, London, 1976, p.8

8 Paul Nash quoted in Herbert Read (ed), *Unit One*, Cassell & Co., London, 1934

9 Roger Berthoud, *Graham Sutherland, A Biography*, Faber & Faber, London, 1982, p.56

10 Roger Berthoud, *Graham Sutherland, A Biography*, op. cit., p.41

11 Graham Sutherland quoted in Martin Hammer, *Bacon and Sutherland: Patterns of Affinity in British Culture of the 1940s*, Yale University Press, London & New Haven, CT, 2005, p.46

12 Graham Greene, *A Sort of Life*, Bodley Head, London, 1971, p.165

13 Roger Berthoud, *Graham Sutherland, A Biography*, op. cit., p.56

14 WB Yeats, *The Phases of the Moon*, *Selected Poetry*, Macmillan & Co. London, 1962

15 Geoffrey Household, *Rogue Male*, Penguin, London, 1978, p.80

16 The science fiction novel *Riddley Walker* by Russell Hoban, 1980

17 Russell Hoban, *Riddley Walker*, Bloomsbury, London, 2002, p.196

18 Roger Berthoud, *Graham Sutherland, A Biography*, op. cit., p.63

19 Daniel Farson, *The Gilded Gutter Life of Francis Bacon*, Vintage, London, 1994, pp.33–34

20 Graham Sutherland, 'Welsh Sketch Book', first printed in *Horizon*, Vol. V, No.28, April 1942, reprinted in Martin Hammer (ed), *Graham Sutherland: Landscapes, War Scenes, Portraits 1924–1950*, Scala, London, 2005, p.68

21 John Cowper Powys, *Autobiography*, John Lane, London, 1934

22 Graham Sutherland, *Sutherland in Wales: A Catalogue of the Collection at the Graham Sutherland Gallery,* op. cit., p.8

23 Graham Sutherland, 'Thoughts on Painting', *The Listener*, 6 September 1951, reprinted in Martin Hammer (ed), *Graham Sutherland: Landscapes, War Scenes, Portraits 1924–1950*, op. cit., p.145

24 Philip Larkin, 'The Life with a Hole in It', 1974, *Collected Poems*, Faber and Faber, London, 1988

25 Graham Sutherland, *Sutherland in Wales: A Catalogue of the Collection at the Graham Sutherland Gallery,* op. cit., p.6

26 Albert Camus, *Lyrical and Critical Essays*, Vintage, New York, 1970

27 *The Halfway House*, directed by Basil Dearden, 1944

28 T.S. Eliot, *Little Gidding*, *Four Quartets*, Faber & Faber, London, 1944

Monuments and Presences[1]

Brian Catling

> 'Painting ... becomes a series of advances and / retreats in so far as one must often destroy what one has discovered in order to make a further advance.'[2]

A landscape sprawls bare, but radiant.

Larger, than the contours of its modest scale and with all its familiarity forsaken and exchanged with colours from another world. And yet we know it. Some part of us has walked here in that wisdom of experience that is always inexplicable. The trees and rocks are conspiring to transform, straining to lose their innocence and sulk in menace or to brood in foreboding. But there is no gloom here, rather brightness that stings and tingles, and occasionally wallows into inhospitable twilight. Surely this is the dominion of a dream, fringing nightmare?

No it's Pembrokeshire.

The artist tells us so. There is nothing of the phantasmagorical or surreal here. These are images rendered from memory. Wordsworthian recollections that sanctify the turbulence of the modern world by re-imagining 'the miracle of natural order' through a lens where all the distortions are sublime, even the creepy ones.

> Thou, whose exterior semblance doth belie,
> Thy Soul's immensity;
> Thou best Philosopher, who yet dost keep
> Thy heritage, thou Eye among the blind,
> That, deaf and silent, read'st the eternal deep,
> Haunted for ever by the eternal mind[3]

Surrealism as a movement never existed in England. The painted fictions of unruly dreams and their sinister shadows could not find a believable perspective or an audience for their jarring stillness. The main reason why surrealism did not flourish is that it already exists in everything that occurs in this corner of the Earth; especially entwined in the metaphoric weight between words and most blatantly in the British sense of humour. Europe had to breed surrealism to cope with its own pride, shifting boundaries of brutal citizenship. And the biblical pressure of the solemn Freudian gospels. Taken without the slightest tincture of irony.

But post-war Britain did need something like it to earth the spite of the dark memory of conflict. It needed a conduit, a conductor to ground the intimacy of recent horrors. A serious, trustworthy sin-eater to convert the ache of loss and the experience of atrocity into a form of palatable art. Continental intellectuals with incomprehensible moustaches and preposterous anarchistic lies about wine racks and urinals could not be trusted. Only solid Englishmen in flannelled common sense were encouraged to lay bare our humanity by steadfastly examining rocks, roots and pebbles and allowing us to see that Belsen had always existed, skulking in the shrubberies or occulted in the rose garden.

Henry Moore and Graham Sutherland were perfect: a down-to-earth Yorkshire man and a made-up toff. The psychological disturbance in their work used the new abstraction to curve the shock and glance the blow and thereby let us admire the surprise of craft before tasting the wince. Francis Bacon never got past the censor even though he was often lumped in with them. The only thing he really ever shared with Sutherland was the delight of fierce orange backgrounds. They both seemed to work with a job lot of the colour that was politely called 'russet' by connoisseurs, but in reality was closer to an industrial oxide that reeked of alarm and warning.

This was all a long way from his apprentice prints of pastoral Kent that owed so much to Samuel Palmer. Being shuttered between those visionary Arcadian icons and the congealed ferocity of Francis Bacon's saturated interiors, it is not surprising that Sutherland's pictures seem disjointed, oddly muted and sometimes coy. It's not weakness or dilution that holds back a greater impact, it is more the timing of the subtle mechanism of implication that owns them; suggestion rather than statement that unwinds their meaning. The viewer is not assailed or overpowered, rather they are enticed to step closer and even enter the tightness of neurotically furled gardens and scratched landscapes. It is only inside that the true nature and meaning of the surroundings becomes apparent. Like a scent that is out of place, a sound that has slipped its origin. This form of liminal entrapment is deeply embedded in literature, where otherworldliness and a sense of apprehension is often conjured by understatement or the obsessive description of static detail.

The haunted fiction of MR James is the quintessential cannon of this eerie unveiling. And Sutherland's Pembrokeshire paintings hold a parallel unease. However, he never made such a comparison. Instead, he often claimed innocence of the darker motifs of violence and sinister threat that lurk in the innards of his marks and colours. He also shifted responsibility for their recognition firmly into the eyes of his beholders.

It has been said that my most typical images express a point of view dark and pessimistic. That is foreign to my mind. The precarious tension of opposites (happiness and unhappiness, beauty and ugliness) so near the point of equilibrium, can be interpreted, perhaps, according to the predilections and needs of the spectator with delight or horror, as with the taste of bitter-sweet fruit. The painter is a kind of blotting paper; he soaks up impressions; he is very much part of the world.[4]

Adopting the defence of passive absorption and artistic mediumship, workmanlike skills seem to be all that is needed and this leaves little room for debate, speculation or self-awareness. The meaning of each work is summoned blind by the process and infolded in the paint. Each work instigates, breeds and cages its own personality without the directed will of the painter.

Sometimes this is true. But even the most reclusive of artists cannot avoid the critical analysis of others. Multiple interpretations of individual graphology and collective conclusions will follow the artist back to the loneliness of their studio, and in some way will demand to be answered. Approval is the most dangerous parasite to dwell with. Constant approval makes the brushes sticky and turns the seances into a puppet show. It is also deeply addictive.

The sea change that dethroned Sutherland from his inflicted title of 'Britain's Greatest Modern Artist' was fast and merciless. He was totally unprepared for the number and vicious-ness of the rats that turned. He escaped their sneering attacks by taking a self-imposed exile in the South of France. For 15 years the glorious sun and the dinner party chatter bleached his imagination and erased the convoluted identity that once existed in the modest domestic room that he used as a studio: the place where he dissected landscape, insects, thorn trees and humanity, and reassembled them with a genius of incorrectness. The oak-beamed cottage room where he crucified himself with ropes, to hang in disjointed reflection so that he could feel the strain and watch its naked tension in the mirror below.

In the dark glass swam both his Christs: the much praised re-working of Grünewald's apparition of twisted pain, and the greatly maligned tapestry for Coventry Cathedral. An eerie and unnerving presence of an androgynous Messiah in triumph. The gigantic work that was the spark to his critical downfall is still underestimated, still waiting to be rectified by a newer generation of unbiased eyes.

Seeing films and photographs of Sutherland from after that time it is obvious that he was

one of a departing species: a 'Gentleman Artist' at ease with high society; cigarette and cocktail glass held in abeyance to the oils and turpentine, and all the endless silent hours of inventing a visual language for re-imagining existence.

The gaunt dapper man in the frame is interchangeable with Ian Fleming or Dennis Wheatley and a flock of other post-war men whose success and urbanity treacherously conspired towards a condition of disappointed auto-cannibalism.

Whatever we think about his motives, strengths and weaknesses, they should not be confused with his talent, originality and flair.

The core of the paintings still remains charged. The insects and the spiked heads. The landscapes from the battlefield to the spray-ripped coasts of Wales have all been wrung out of the complex motors of a unique imagination. And there is still a quality of churning in many of the paintings, as if both the hand that operated them and the pigments that held them in sight are unstill and capable of deep seismic shudder, causing a realignment of meaning somewhere outside the periphery of our lazy sight.

'The unknown is just as real as the known and must be made to look so.'[5]

1 Graham Sutherland, 'Thoughts on Painting', *The Listener*, XLVI, 6 September 1951
2 Graham Sutherland quoted in Noël Barber, *Conversations with Painters*, Collins, London, 1964, p.46–7
3 Extract from William Wordsworth, *Ode: Intimations of Immortality From Recollections of Early Childhood*, 1804, first published in *Poems, in Two Volumes,* 1807
4 Graham Sutherland, 'Thoughts on Painting', op. cit.
5 Graham Sutherland, 'On the Artistic Process', in Robert Melville, *Graham Sutherland*, Ambassador Editions, London, 1950

Sutherland's Metamorphoses

Alexandra Harris

Never has the world seemed so vitally unfinished as in the work of Graham Sutherland. Everywhere we look it is metamorphosing. The mountains of Pembrokeshire are not to be relied on for their solidity: no sensible climber would venture here because the earth trembles on the verge of volcanic eruption; with every moment the shifting sun changes the shape and constitution of the hills. The four elements keep changing places, while the familiar taxonomy of 'animal, vegetable and mineral' no longer seems very helpful for sorting things out. Gnarled oak trees froth up and arch like breaking waves; molten steel aspires to fire.

The notion of 'finish' seems irrelevant here. Painterly finish is not much use when all endings are provisional, mere pauses for breath (sometimes more like the gasp of the painting *Twisted Tree Form*, 1944), (p.93), before the world moves on again. But even words like 'before' and 'after' seem fallacious because time has forgotten its boundaries. In a prophetic Welsh sunset or the cool moon landscape of an open mine, we are surveying a fantasised future, a working present, a geological past, and a biblical genesis that seems still to be in progress. There is no sign of our reaching the restful seventh day just yet.

Sutherland first went to Pembrokeshire in 1934, and his responses to it transformed his art. He continued to paint subjects from the landscape around St Davids and Sandy Haven all through the 1930s and returned to it during the war years whenever he could. When he sketched out maps of the area and marked his painting spots, the markers were intimately clustered: six paintings here, two more just to the right, five on the same spot but the opposite direction.[1] He particularly loved the tree-lined lane leading down to the estuary at Sandy Haven, so he went back there again and again.

Sutherland was not looking for picturesque views, though Wales had provided views enough for generations of artists before him. He worked instead towards symbols of what it felt like to be in this place, and symbols of the natural forces that seemed so much in evidence. Among the shadowy boles of a protuberant branch, signs of fertility and decay fight for precedence. Strokes of vivid green compete with black. Or an ancient story of struggle and survival is compressed into an awkwardly twisting bit of gorse sitting for its portrait.

Still life, landscape, portraiture: there is no telling which is which. These natural forms have character and agency. The art historian Frances Spalding once commented that 'Sutherland's Wales, mediated by Surrealism, is closer to Birnam Wood than to the Wales of Richard Wilson

or JD Innes.'[2] It is a brilliant comparison. Like Malcolm's army in *Macbeth*, Sutherland deals in anthropomorphism, making branches and human limbs transferable. It would be no surprise in his Pembrokeshire to find a forest on the move.

Though his work can look deathly, decay is only another form of fertility for Sutherland, and is part of the ongoing creation. His oak trees may be misshapen, but they have warped into carnal 'association' and are about to reproduce. Even his rocks and stones are breeding grounds, which is why he paid special attention to lichen. 'The surfaces are speckled with lichens', he observed in an essay on Brimham Rock in Yorkshire: 'It is as if, by a kind of prodigality of nature, the natural processes must add to the patterns inherent in the matter.'[3] Gorse, moss and lichen are his heroes: organisms that conjure life from air. When he paints a more obvious sign of fecundity, a cornstook for example, the result is an ecstatic shaft of yellow, which sets the whole landscape alight.

Look again at the corn in *Cornstook in Landscape*, 1945–46, (p.103), however, and it becomes an underground cavern of lava about to erupt and pour down the hills. This is a typical case of double perspective, which turns distances into depths. *Road Mounting Between Hedges: Sunrise*, 1940, (p.101), is just what it says, but it is also a cross-section through the earth, showing the compacted strata beneath a smoking summit. So we are also looking back in time, surveying the construction of the earth in sedimentary plains and igneous effusions.

Such a place throws up curious monuments. Sutherland noted in his 'Welsh Sketch Book' the boulders and 'rocky cairns of every size'.[4] This was the county from which the bluestones of Stonehenge were carried. In tribute, Sutherland organises his own rites and ceremonies, aligning himself so that steep roads seem 'to pinch the setting sun'.[5] His roads ought to stop at the horizon like other people's roads, but instead they continue tentatively, experimentally into the sky, becoming sunbeams or mysterious force lines, linking earth and light.

When Kenneth Clark recruited him as an Official War Artist, Sutherland worried that he would not know how to paint the subjects assigned to him. He was a painter of mountains and exposed roots blinking moleishly as they appear above ground. How could he turn himself at high speed into a recorder of urban devastation? But it turned out that all his work in Wales had been a form of training for this graver task. On the shoreline he had painted flotsam: strange combinations of trees and stones; now he painted the flotsam of the Blitz, which was thrown up by fire rather than by water.

In the City of London he painted the debris of warehouses and office blocks, buildings that had seemed solid and imperturbable. Sutherland's ruins groan a little and settle into new

forms in the silence – and these are silent pictures remembering the 'absolute dead silence' of the mornings after the raids. Sutherland looked particularly at metal, the substance we rely upon to be unbending. Girders should hold a building up, but here they are twisted in upon each other. Lift shafts should enable safe ascent, but here they have crumpled to the ground. *Fallen Lift Shaft*, 1941, (p.58), is a sorrowful inversion of a fluttering kite, the arabesques of its tail hardened into rigor mortis. To Sutherland the collapsed shafts looked like wounded animals. He recalled that 'One shaft in particular, with a very strong lateral fall, suggested a wounded tiger in a painting by Delacroix.'[6] It was a symbol of power curtailed.

After the Blitz, Sutherland was sent to record a series of industrial sites that were fuelling the war effort. He was faced again with the subjects he had first found in Pembrokeshire: earth, rock and fire. Where previously he had imagined his way under the hills, now he went down into Cornish tin mines. He saw immediately the suitability of the subject: 'The setting could hardly be more "my line of country"' he told Kenneth Clark, in a letter which showed his words climbing up a mine shaft from deep underground.[7] Annotating his sketches with sensations to remember, he recorded the 'very strong feeling of shut-in-ness & weight of stone ... very mysterious'.[8] He rendered that shut-in-ness as if he had entered a body and were looking down hot, fleshy passageways.

At steel works in Cardiff he drew the flaming mouths of the furnaces. And then, coming out from the heat and enclosure, he painted the opencast coal mine at Pwlldu near Abergavenny as a cool lunar landscape in whites and blues. The volcanic mountains of Wales, formed in white heat, had fascinated him. Now he was fascinated by the man-made excavations which were redrawing the horizon line bucket by bucket in the white cold of night. He drew the ropes and pulleys of the draglines haltingly, in pencil. Taut, nervy, precarious: here are the means by which man has to move the mountains.

The Italian critic Roberto Tassi reminds us that with these paintings Sutherland was revisiting a subject that had compelled Romantic predecessors like Philip de Loutherbourg and Joseph Wright of Derby.[9] He was working in a long tradition of artists who had felt both the allure and the hellishness of Satanic mills. It is a tradition where science and mysticism meet. When Wright of Derby paints an iron forge, he borrows the composition of nativity scenes – raw and rustic, with the molten iron forming a miraculous central light from which onlookers have to shield their eyes. His inventors gather round to witness magic rites; his alchemist is both a wizard and a chemist.

So too with Sutherland, who is interested both in magic and in material states. When he

painted the lime quarries he was making a geological study. In the mines and foundries he scrutinised mechanisms, processes and skills. Having trained for a year in 1919 as an apprentice railway engineer in Derby, he understood much of the machinery. He knew what it took to beat a rivet – with both power and precision – into the required shape for an engine. When he painted furnaces in the steel foundries he was revelling in scenes worthy of Dante's *Inferno*, but he was also paying tribute to the endurance and practicality of the human beings who have this primal blaze under control.

In all his wartime paintings he observed and respected *work*. And he approached his own tasks as if he were clocking-on for duty. All his life he kept long but regular hours, reaching a productive accommodation between freedom and routine. An element of shock was crucial to his art: subjects often suggested themselves by surprise as he walked through a landscape. But he needed these surprises to occur fairly reliably. This was one of the reasons he gave for moving South. He was in search of bright sunshine, which often lit up an arresting combination of forms, and since bright sun does not keep regular hours in England he relocated for large parts of the year to the Côte d'Azur.

His methods were systematic as he moved from small outdoor sketches to studio variants, which might be carefully squared up and transferred from a sheet to a canvas. Those geometric grids were a form of control by which he framed his unruly shapes and temporarily pinned them down. This carefulness is legible in the work of course, as the novelist William Boyd observed: 'There is something dogged about the way the initial serendipitous *coup d'oeil* is worked up and worked on until its fitness as the subject of a painting is deemed suitable. Patience, thoroughness, endless practice, precision....'[10] A dogged visionary then? It need not be a contradiction in terms.

When, in 1944, Sutherland featured in a short film on war artists called *Out of Chaos*,[11] he was shown at work in a lime quarry near Buxton in Derbyshire. He might very well be an industrial architect or a manager coming to check the site: only his sketchbook gives him away. He wears a neat pinstriped suit, determinedly dressed for the office even if his office was in the open air. But he wanted to ally himself with manual labour too and therefore insisted on a hard hat, which suggests the physicality of his task. The suit and the hard hat showed that Sutherland was a daylight kind of man, engaged on a job of work. But he was at the same time an artist of unknowable mystic rites.

He always kept his distance from mysterious Wales, that place of 'exultant strangeness'.[12] Though he returned to Pembrokeshire frequently, he preferred to live and paint in Kent.

From the window of his studio he looked out on the domestic life of the pub and the village green at Trottiscliffe.[13] He chose not to paint it: ordinary lived-in England was a subject he left to other people. But the steady familiarity of that scene was part of what made possible his molten, morphing art.

When John Read filmed him in the South of France in 1954, Sutherland appeared as a dapper, congenial figure.[14] He walked through his sunny garden and talked easily about his work. But part way through a sentence he took from his breast pocket the darkest of glasses, and in the next moment he was masked, shielded, secret. He was ready to become a shadow-figure in the long grasses or to await the setting of the sun.

1 Sutherland's maps are reprinted in John Hayes, *The Art of Graham Sutherland*, Phaidon, London, 1980, pp.18–19

2 Frances Spalding, *British Art Since 1900*, Thames & Hudson, London, 1987, p.130

3 Graham Sutherland, in Myfanwy Evans (ed), 'An English Stone Landmark', *The Painter's Object*, Gerald Howe, London, 1937, p.92

4 Graham Sutherland, 'Welsh Sketch Book', first printed in *Horizon*, Vol. V, No.28, April 1942, reprinted in Martin Hammer (ed), *Graham Sutherland: Landscapes, War Scenes, Portraits 1924–1950*, Scala, London, 2005, p.68

5 Graham Sutherland, 'Welsh Sketch Book', ibid, p.70

6 Interview for *Telegraph Magazine*, 1971, quoted at length in Roberto Tassi, *Sutherland: The Wartime Drawings*, translated by Julian Andrews, Sotheby Parke Bernet, London, 1980, p.19

7 The letter is reproduced in Roger Berthoud, *Graham Sutherland: A Biography*, Faber & Faber, London, 1982, discussed p.106

8 Annotations to *Miner Emerging From a Slope* reproduced in Hayes, op. cit., p.90

9 Tassi, op. cit., p.13

10 William Boyd, 'Graham Sutherland', review of the Sutherland exhibition at Dulwich Picture Gallery, www.williamboyd.co.uk, 2005, accessed by author online 2011

11 *Out of Chaos*, directed by Jill Craigie, 1944

12 Graham Sutherland, 'Welsh Sketch Book', in Hammer, op. cit., p.69

13 The studio in The White House at Trottiscliffe was described by Robert Melville in *World Review*, February 1952, in Hammer, op. cit., p.170–72

14 *Graham Sutherland*, directed by John Read, narrated by Rex Warner, BBC Television, 1954

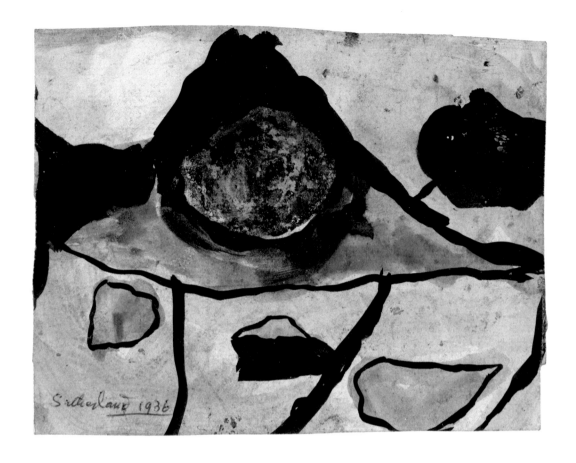

Mountain Landscape 1936
Gouache on paper
9.7 × 12.7 cm
Amgueddfa Cymru – National Museum Wales

Pembrokeshire Landscape 1935
Mixed media on paper
37.8 × 56.7 cm
Amgueddfa Cymru – National Museum Wales

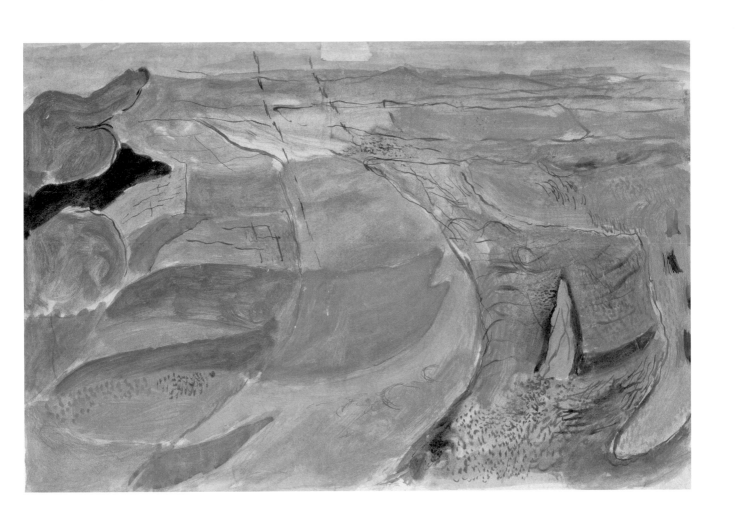

31

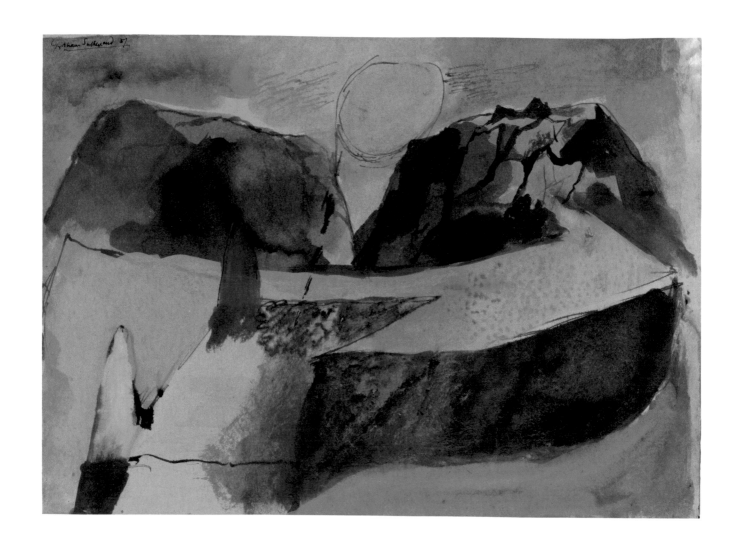

Sun Setting Between Hills 1937
Watercolour on paper
26.5 × 36 cm
Private Collection

Welsh Landscape with Yellow Lane 1939–40
Watercolour, gouache, black ink,
coloured chalks over pencil on paper
69.5 × 49 cm
Private Collection, London

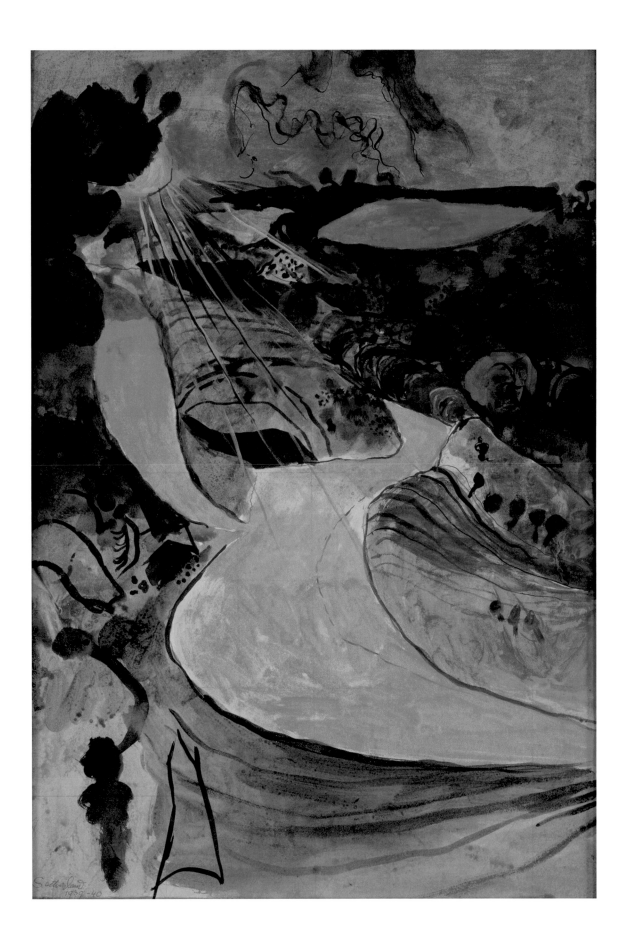

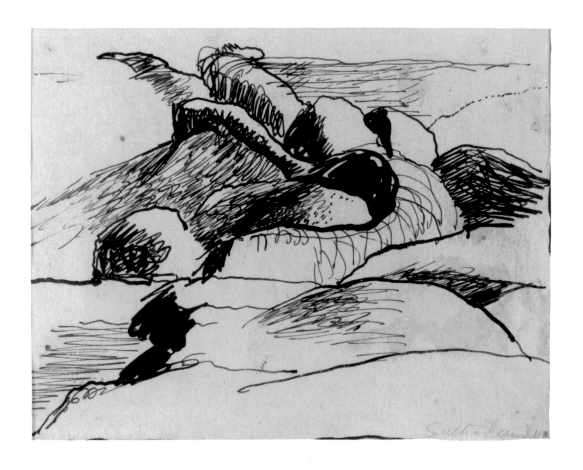

Rocky Landscape 1940
Indian ink on paper
8 × 10 cm
Private Collection

Welsh Landscape 1936
Gouache on paper
35 × 54.5 cm
Private Collection, London

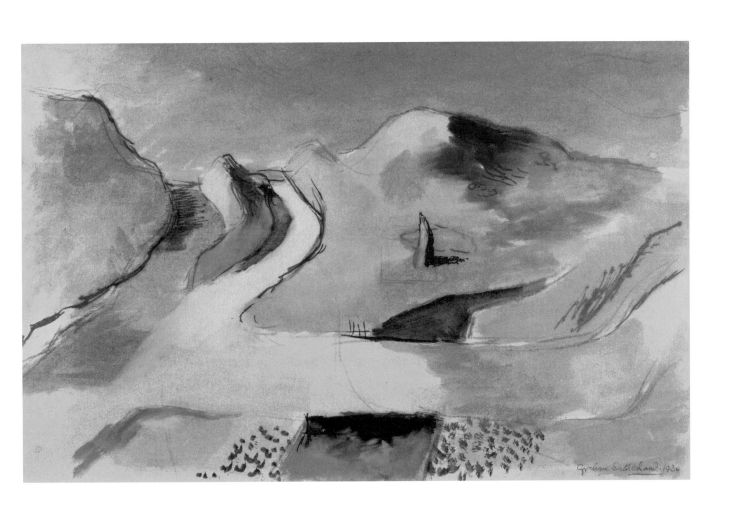

35

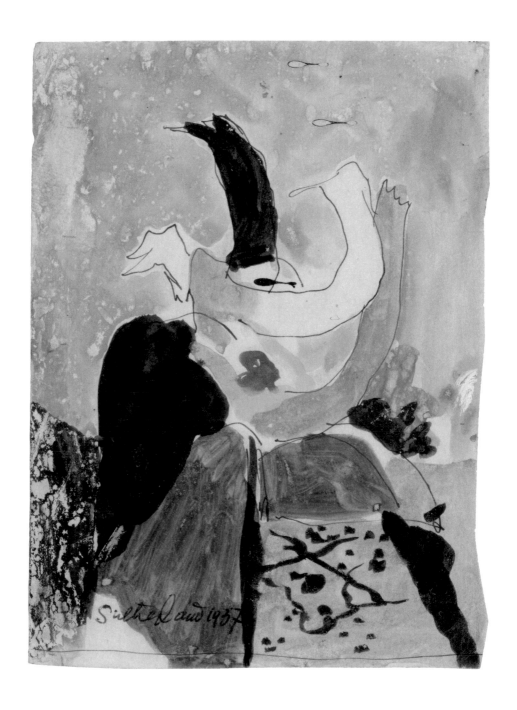

Study for 'Blasted Tree' 1937
Pen and watercolour on paper
11.5 × 8.5 cm
Private Collection

Study for 'Midsummer Landscape' 1940
Pen and watercolour on paper
10.5 × 8 cm
Private Collection

36

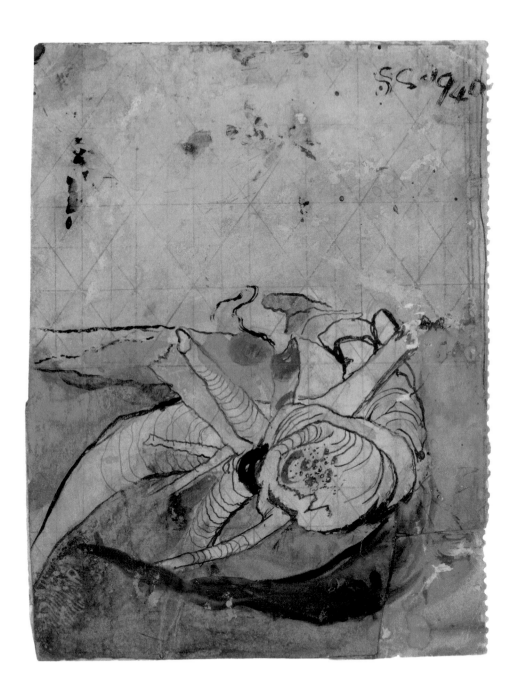

Study for 'Blasted Oak' 1937
Mixed media on paper
34.1 × 25.9 cm
Amgueddfa Cymru – National Museum Wales

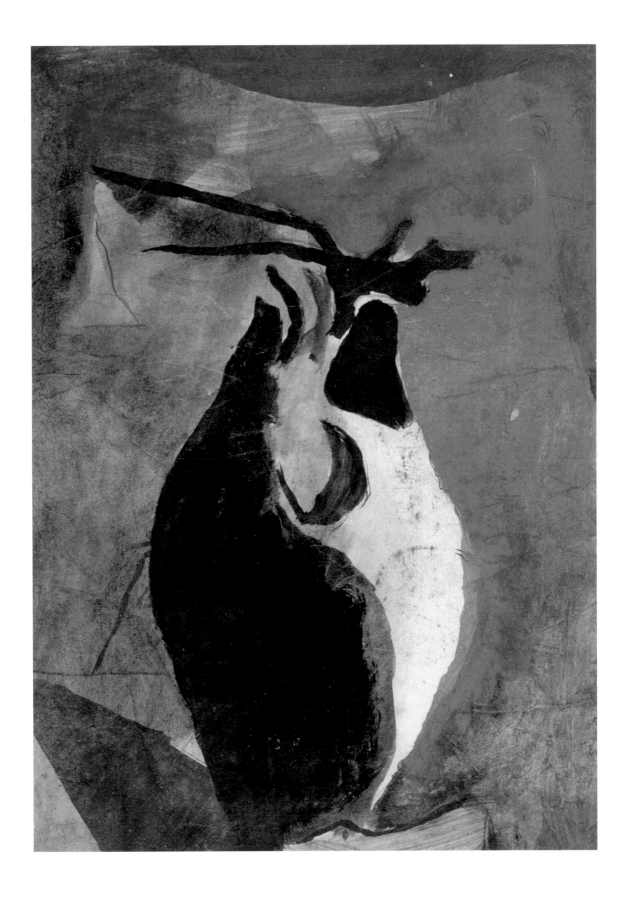

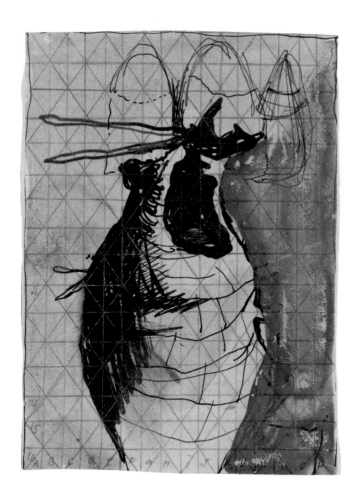

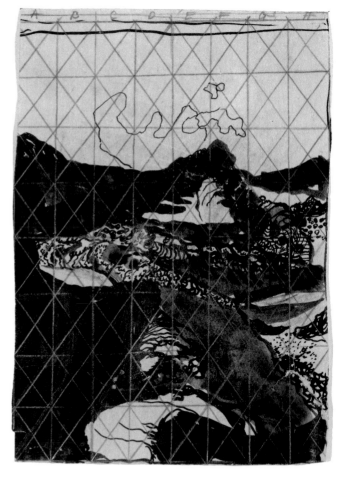

Study for 'Form in Estuary' 1937
Watercolour, pen and ink,
and pencil on paper
9 × 7 cm
Private Collection

**Study for 'Road mounting
between Hedges'** 1940
Watercolour, pen and ink,
and pencil on paper
9 × 7 cm
Private Collection

40

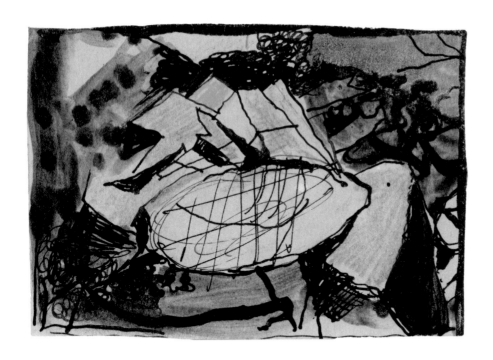

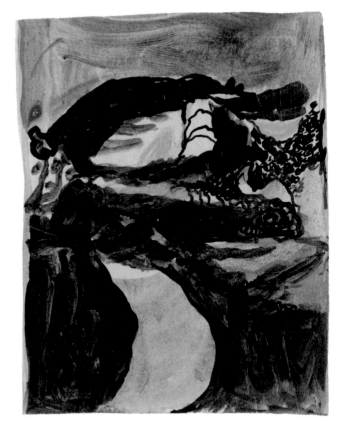

Cairn undated
Watercolour, pen and ink on paper
6 × 8 cm
Private Collection

**Study for 'Road mounting
between Hedges'** 1937
Watercolour, pen and ink on paper
9 × 7 cm
Private Collection

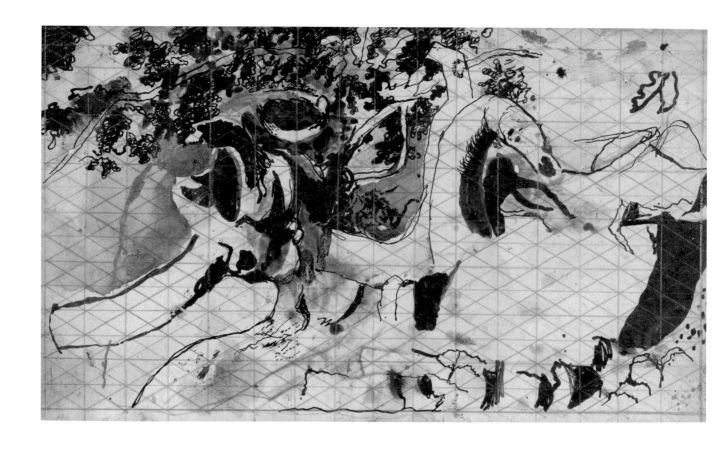

**Drawing of Tree Roots
(with squaring)** c.1939
Pencil, ink and watercolour on paper
10.5 × 18.5 cm
Private Collection

Tree Forms in Estuary 1939
Watercolour, gouache and ink on paper
29 × 22.5 cm
Doncaster Museum Service, Doncaster
Metropolitan Borough Council

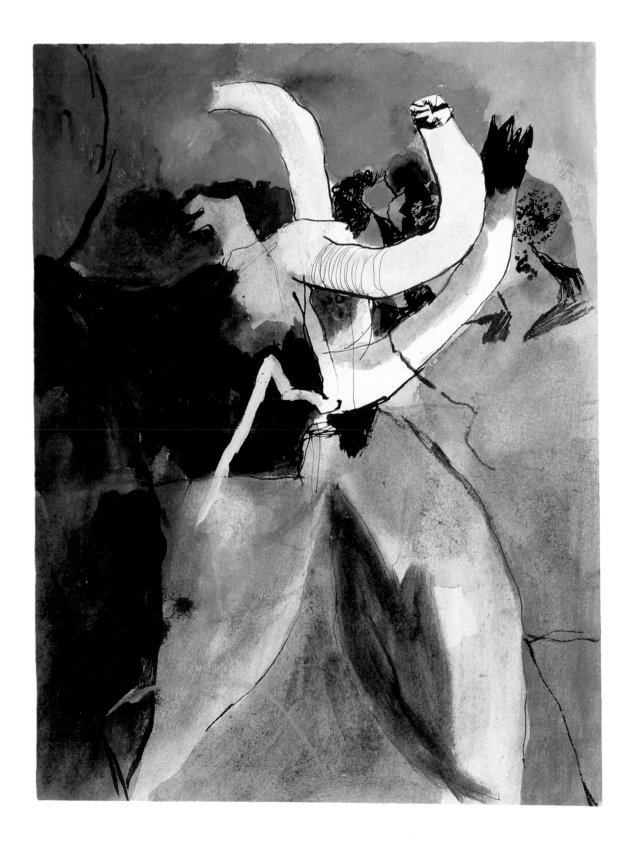

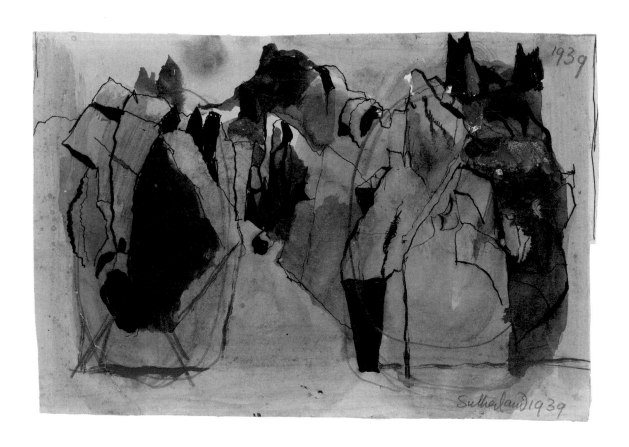

Pembrokeshire Landscape 1939
Pen and ink, with indian ink wash,
white bodycolour and graphite on card
12 × 18 cm
Ashmolean Museum, Oxford

Gypsy Tent 1939
Mixed media on paper
18.1 × 14.2 cm
Amgueddfa Cymru – National Museum Wales

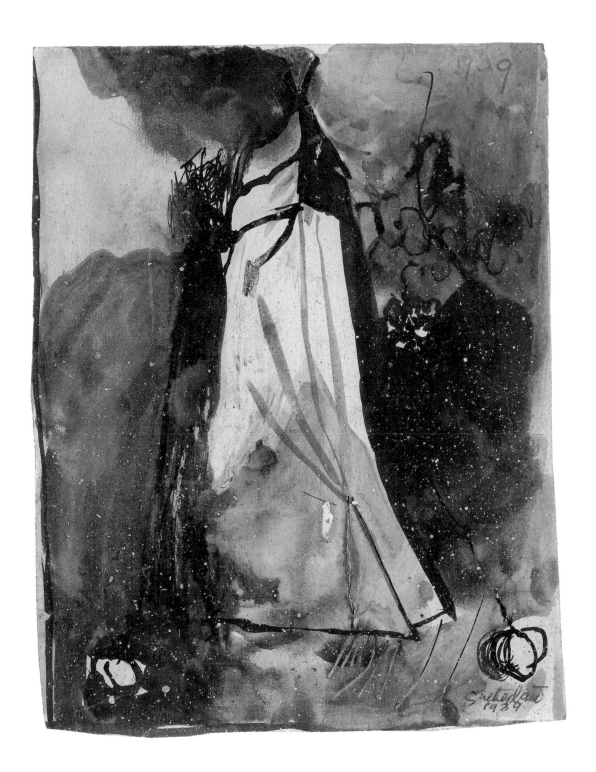

45

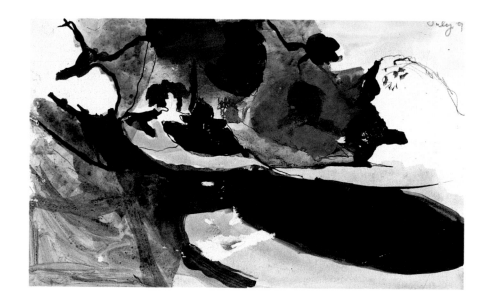

**July 9, No.1 of Five Studies
for 'Entrance to a Lane'** 1939
Ink and watercolour on paper
13.2 × 21.5 cm

**No.5 of Five Studies for
'Entrance to a Lane'** 1939
Ink and watercolour on paper
13.5 × 10.8 cm

Pallant House Gallery (Hussey Bequest,
Chichester District Council, 1985)

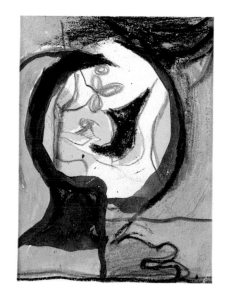

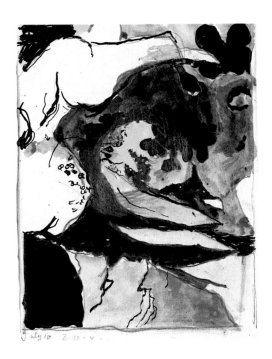

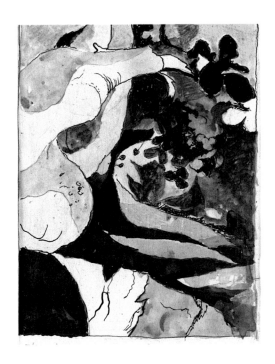

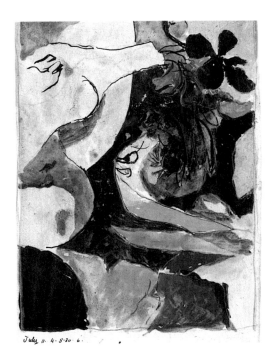

July 10 3.30-4,
No.2 of Five Studies for
'Entrance to a Lane' 1939
Ink and watercolour on paper
15.8 × 13.3 cm

July 10. 4. 5.30-6,
No.3 of Five Studies for
'Entrance to a Lane' 1939
Ink and watercolour on paper
16.1 × 13.3 cm

July 11.4. 5.30.6,
No.4 of Five Studies for
'Entrance to a Lane' 1939
Ink and watercolour on paper
15.8 × 13.3 cm

Pallant House Gallery (Hussey Bequest,
Chichester District Council, 1985)

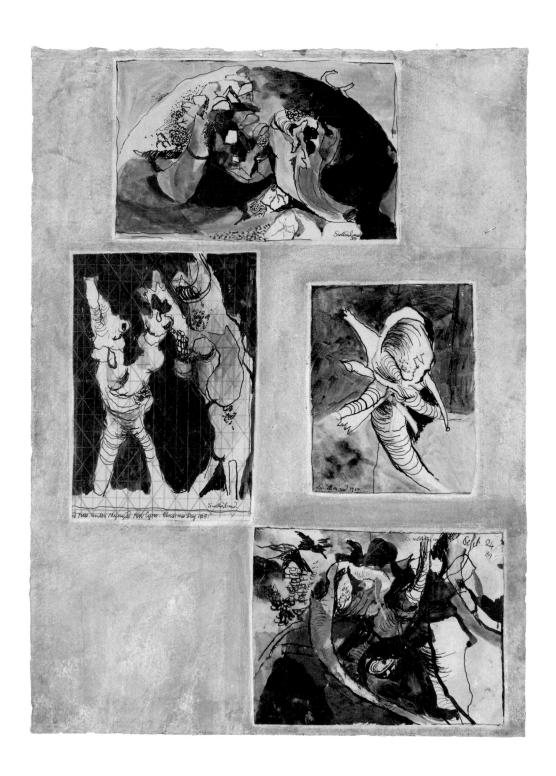

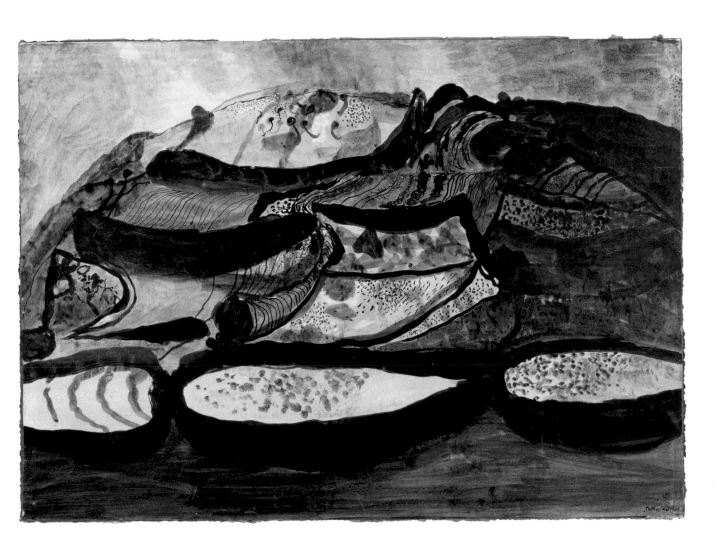

Trees Under Mynedd Pen Cyrm 1939
Pen and watercolour on paper
29.8 × 22.4 cm
Trustees of the Cecil Higgins Art Gallery,
Bedford

**Dark Hill – Landscape with
Hedges and Fields** 1940
Watercolour and gouache on paper
48.9 × 69.8 cm
Swindon Museum & Art Gallery

49

The Wanderer 1940
Pencil, watercolour and
conte crayon on artists' board
47 × 61 cm
Victoria and Albert Museum

Rocky Landscape with Sullen Sky 1940
Watercolour and gouache on paper
48 × 69 cm
Harris Museum & Art Gallery, Preston

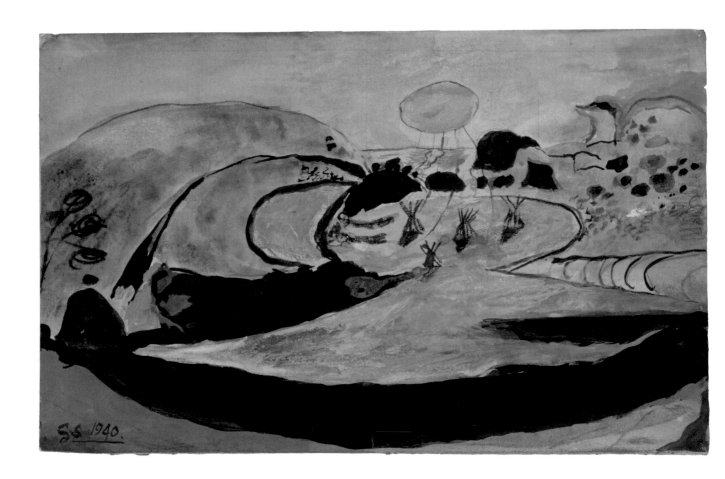

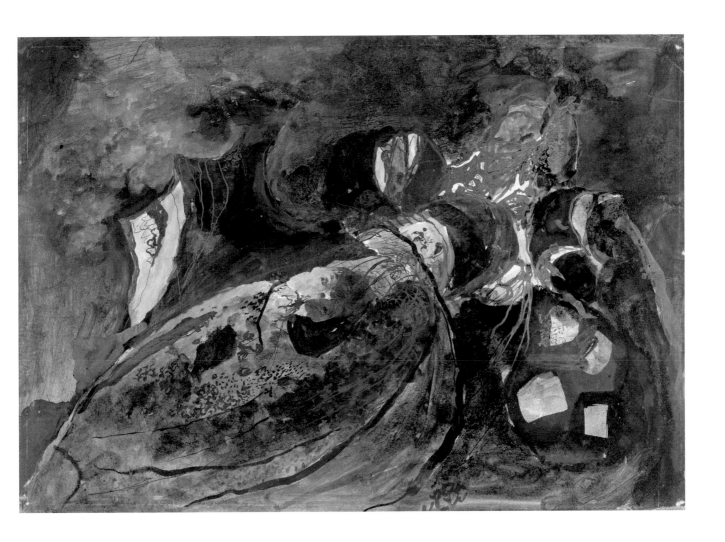

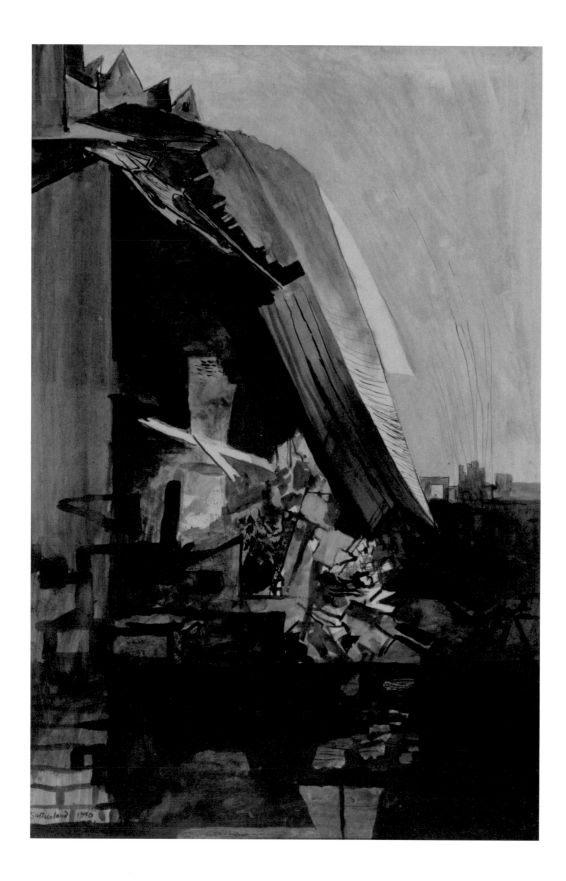

52

Devastation 1940:
Study of a Collapsed Roof 1940
Pen and black ink and watercolour on wove
79.5 × 53.5 cm
Manchester City Galleries
Transferred to Manchester City Galleries
by H.M. Government War Artists' Advisory
Committee, 1947

Devastation 1941:
City Ruined Buildings 1941
Watercolour, bodycolour and chalk on paper
32 × 45 cm
Manchester City Galleries
Transferred to Manchester City Galleries
by H.M. Government War Artists' Advisory
Committee, 1947

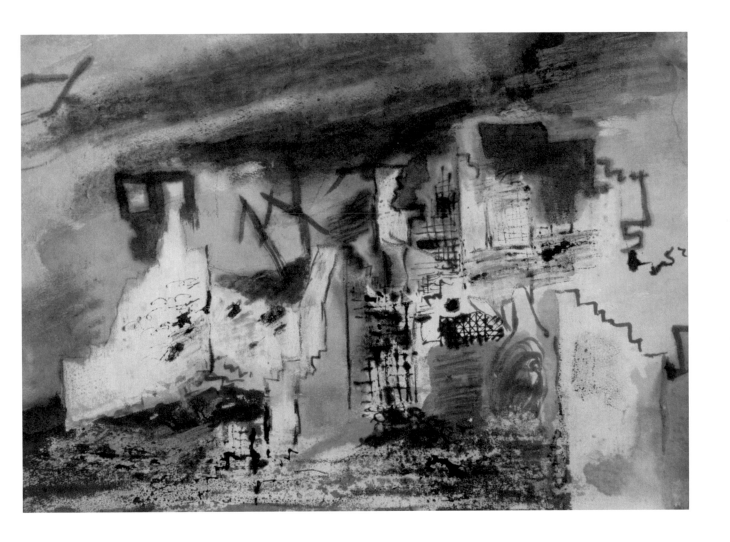

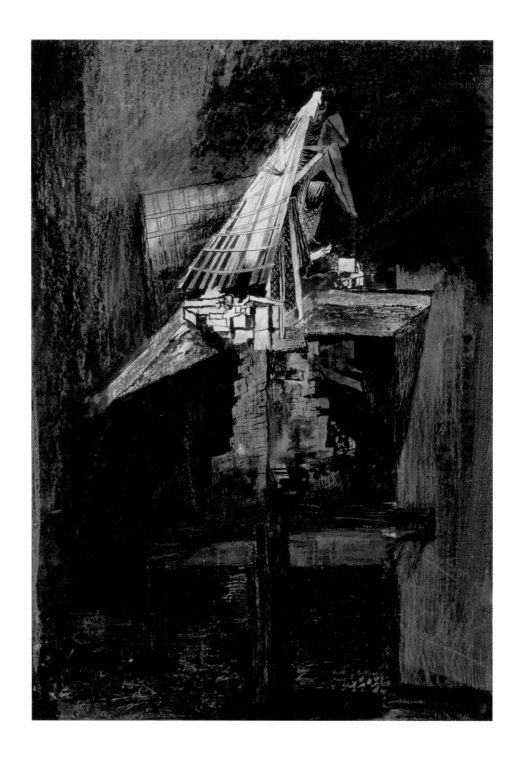

Devastation, 1941: East End,
Wrecked Public House 1941
Crayon, pen and ink, pastel and
gouache on paper
67.3 × 47.6 cm
Tate: Presented by the War Artists Advisory
Committee 1946

Devastation, 1940:
A House on the Welsh Border 1940
Watercolour, gouache and drawing on paper
80 × 54.6 cm
Tate: Presented by the War Artists Advisory
Committee 1946

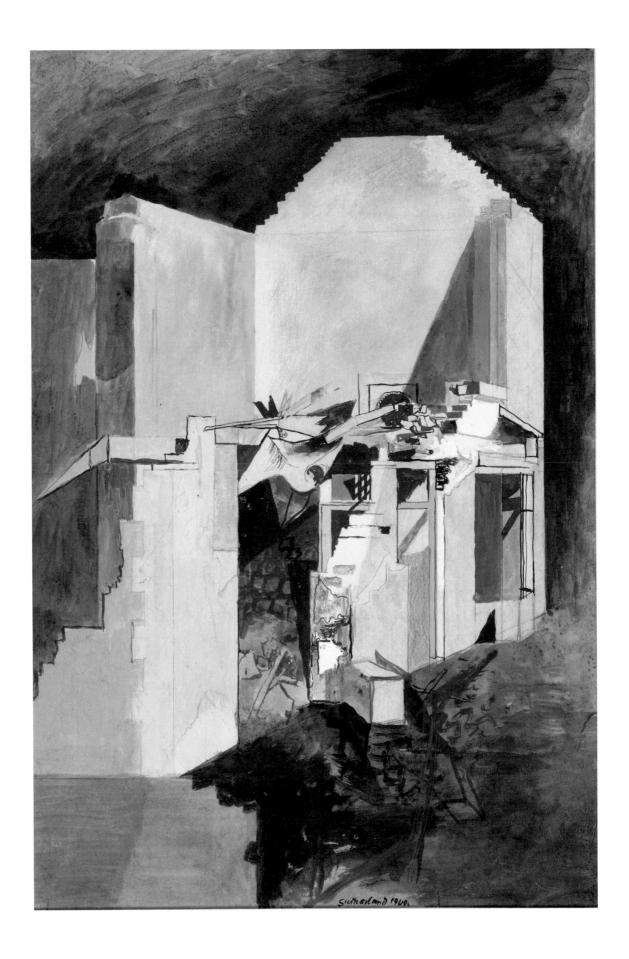

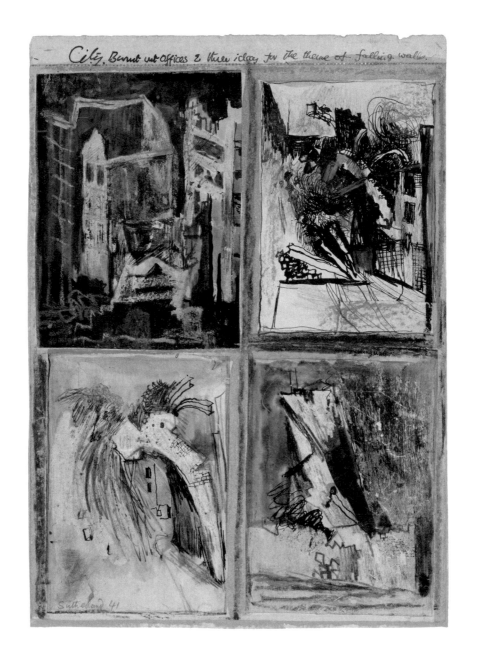

Four Studies of Bomb Damage 1941
Chalk, ink and pencil on paper
25 × 19.2 cm
Arts Council Collection,
Southbank Centre, London

Twisted Girders, Blitz 1941
Mixed media on paper on card
29.7 × 24.5 cm
Amgueddfa Cymru – National Museum Wales

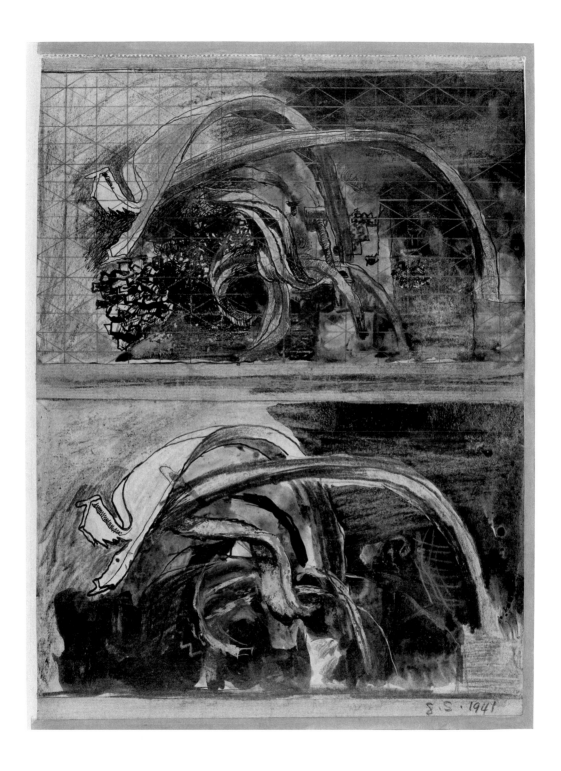

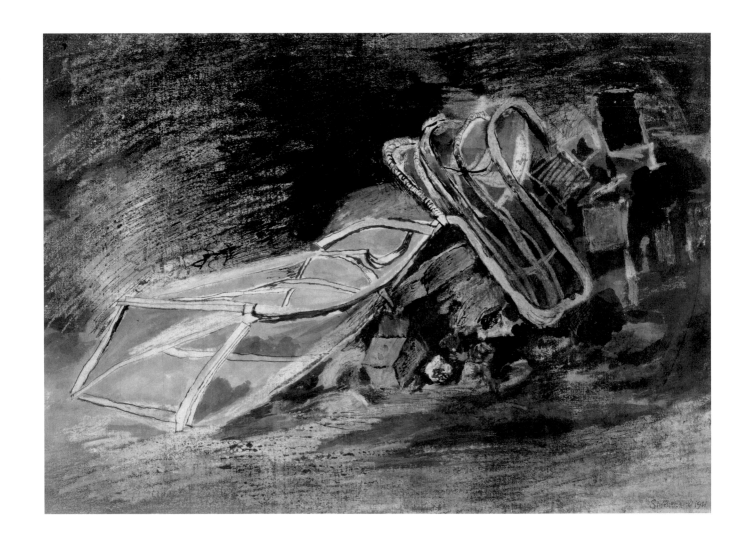

Fallen Lift Shaft 1941
Pen and ink, with chalk, wash
and watercolour on paper
57 × 71 cm
Junior Common Room Art Collection.
With permission of the Warden and
Scholars of New College, Oxford

**Devastation or
The City: Twisted Girders** 1941
Wax, ink, gouache, wax crayon,
watercolour and ink wash on paper
80 × 54.3 cm
The Royal Pavilion & Museums,
Brighton & Hove

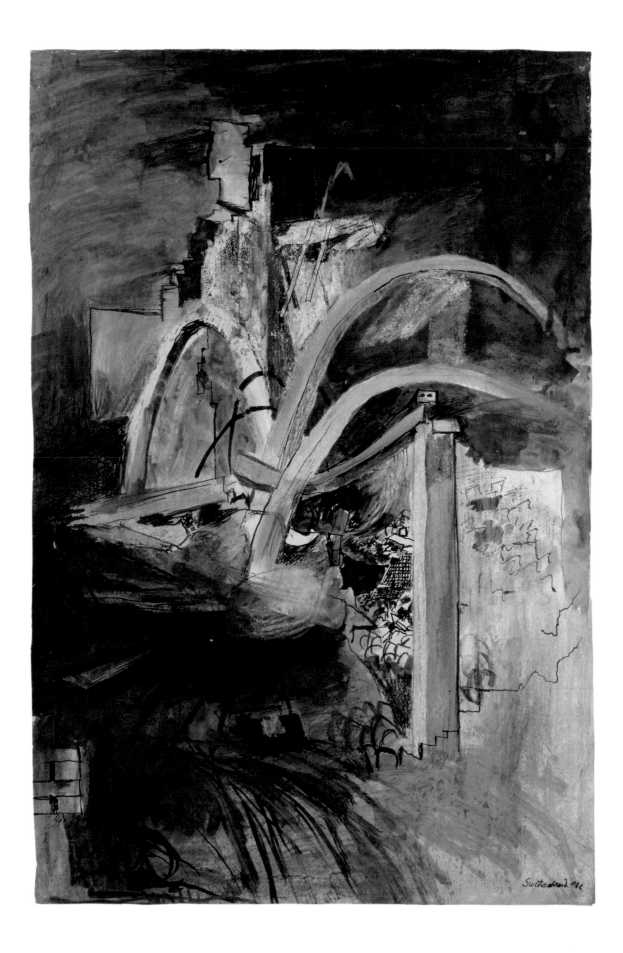

Sutherland 1942

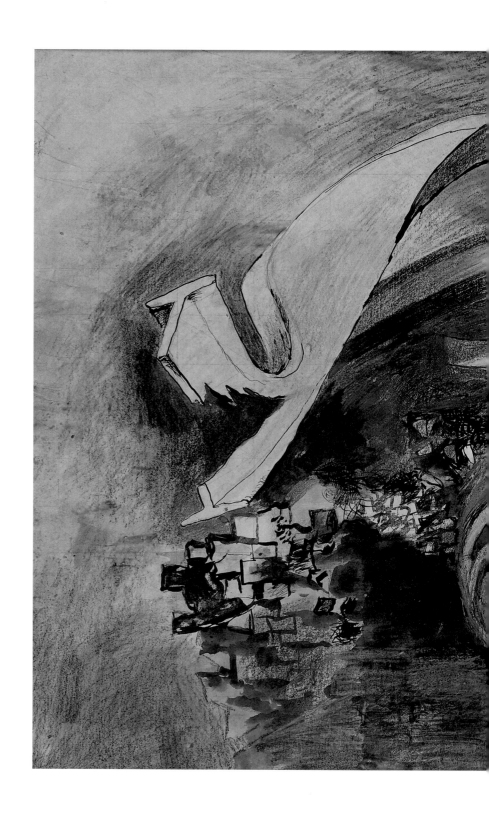

Devastation 1941:
City, Twisted Girders 1941
Gouache, charcoal and ink on paper
55.4 × 112.3 cm
Ferens Art Gallery, Hull Museums

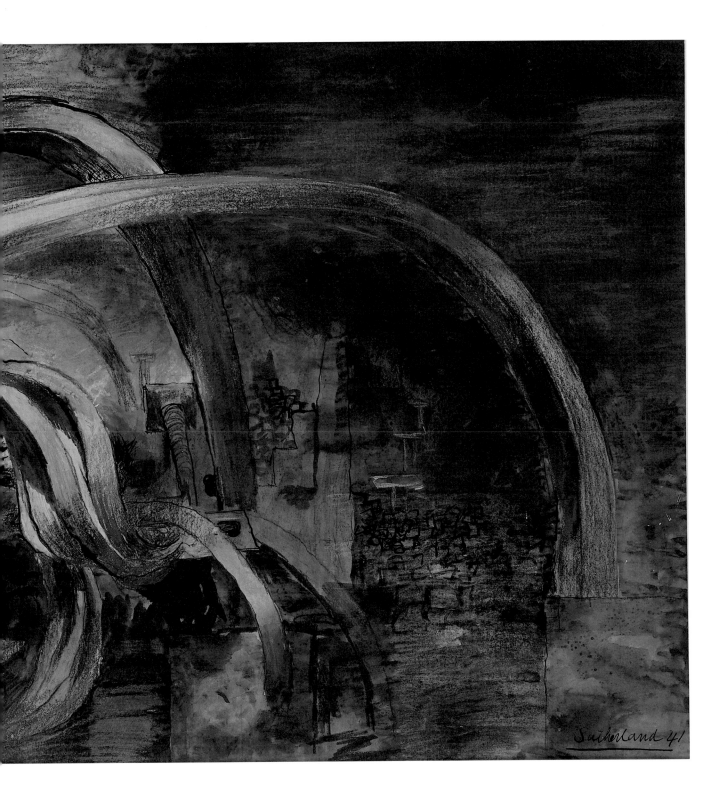

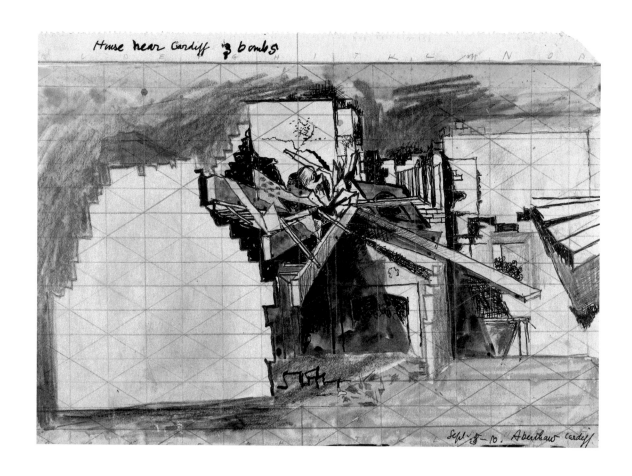

Aberthaw, Cardiff 1940
Mixed media on paper laid down on board
15.7 × 22.4 cm
Amgueddfa Cymru – National Museum Wales

A Farmhouse in Wales 1940
Mixed media on paper laid down on board
16.8 × 25 cm
Amgueddfa Cymru – National Museum Wales

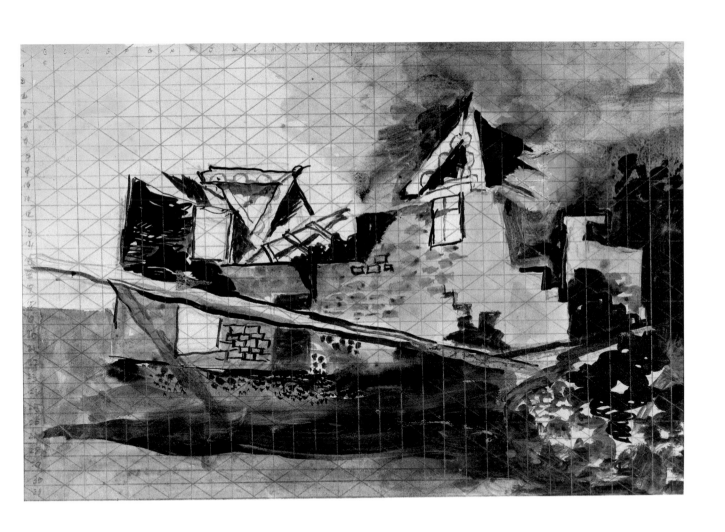

63

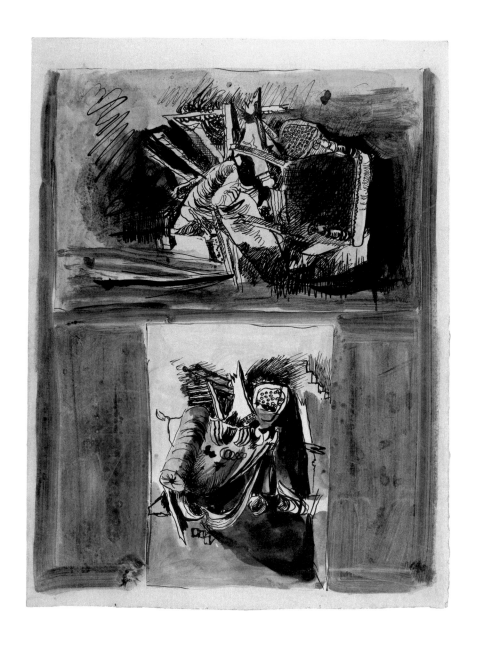

Debris Study c.1940–41
Mixed media on paper laid down on board
13.2 × 20.5 cm
Amgueddfa Cymru – National Museum Wales

Debris Study c.1940–41
Mixed media on paper laid down on board
14.2 × 10.4 cm
Amgueddfa Cymru – National Museum Wales

Cardiff Farmhouse, St. Mary Church c.1940
Mixed media on paper laid down on board
23.5 × 30.6 cm
Amgueddfa Cymru – National Museum Wales

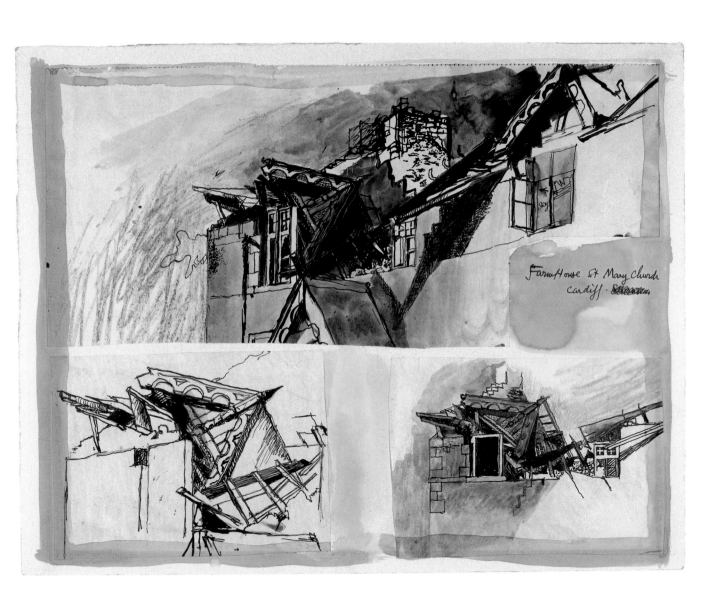

Farm House St Mary Church
Cardiff.

65

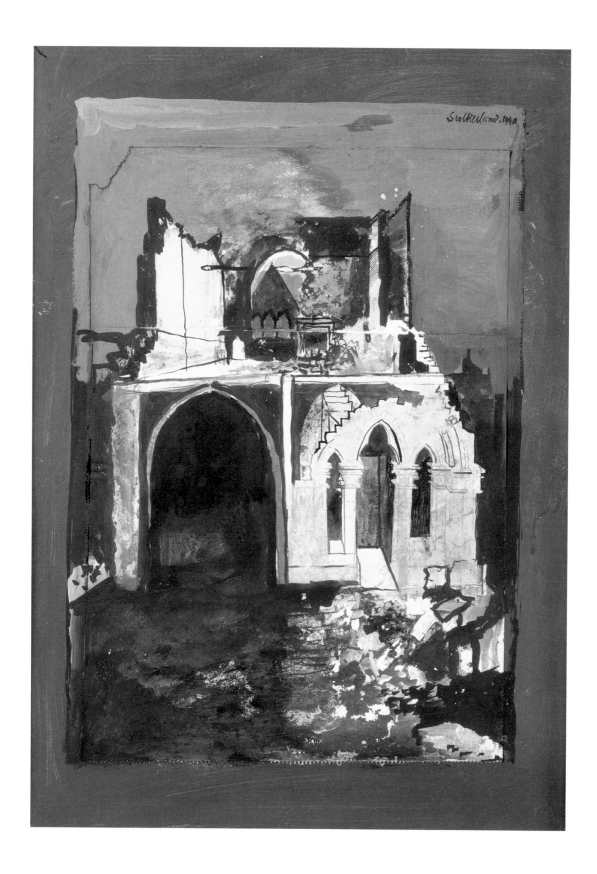

66

Bomb Damage Swansea 1940
Watercolour and gouache on paper
38.7 × 27.9 cm
The Potteries Museum and Art Gallery,
Stoke-on-Trent

Devastation 1941:
City Panorama 1941
Ink, crayon and gouache on paper
30.3 × 44.8 cm
Pallant House Gallery (Kearley Bequest, 1989)

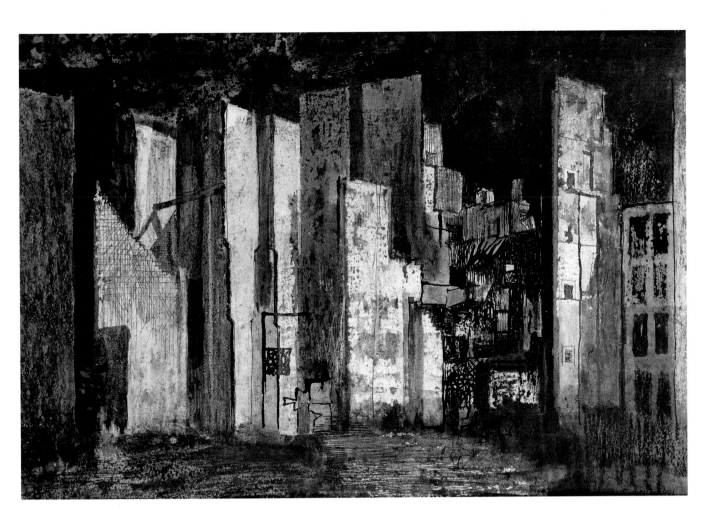

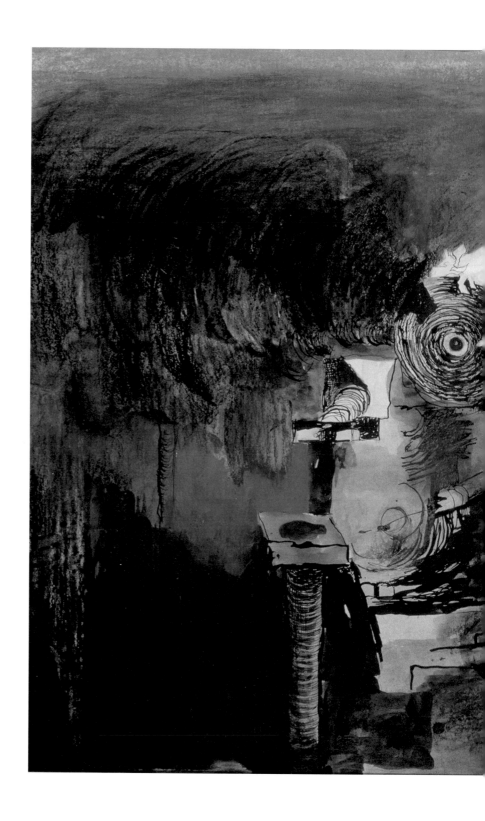

**Devastation, 1941: East End,
Burnt Paper Warehouse** 1941
Gouache, pastel, pencil and pen
and ink on paper, mounted on card
67.3 × 113.7 cm
Tate: Presented by the War Artists Advisory
Committee 1946

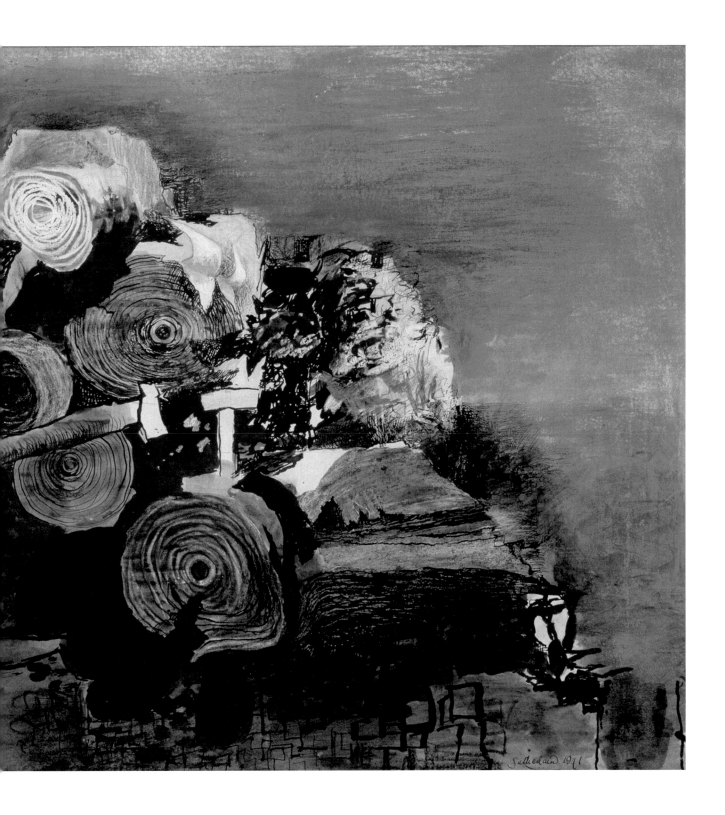

69

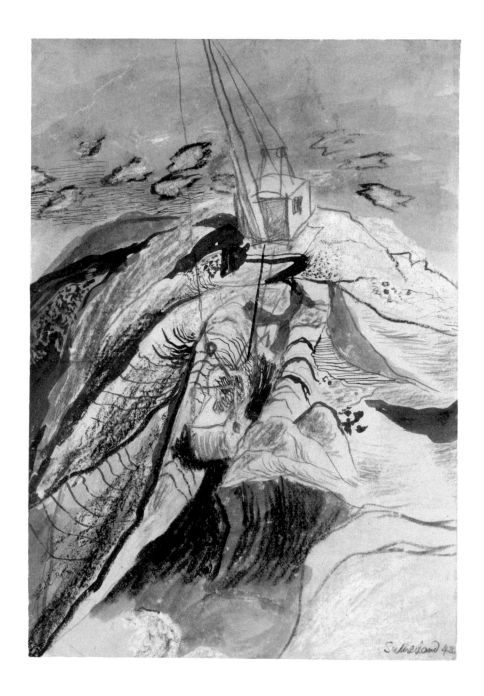

Side of Pit scaled by Dragline 1943
Brush and black ink, black chalk,
soft graphite, pastel and watercolour
42.2 × 30.2 cm
Ashmolean Museum, Oxford
Presented by H.M. Government
(War Artists' Advisory Committee), 1947

Limestone Kilns and Quarries 1943
Chalk, indian ink, wax crayon,
watercolour and ink wash on paper
66 × 57.7 cm
The Royal Pavilion & Museums,
Brighton & Hove

70

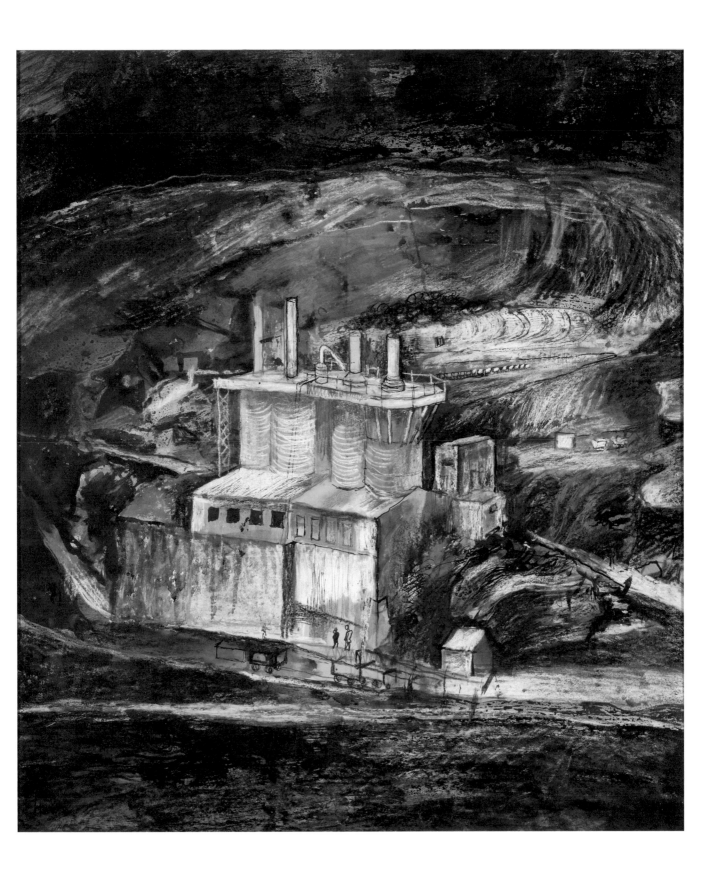

71

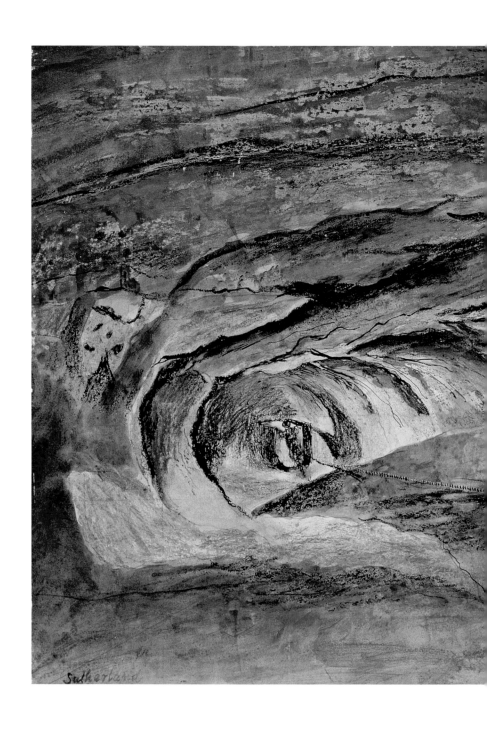

Tin Mine: A Declivity c.1942
Pen, chalk and watercolour on paper,
mounted on board
63.5 × 109.5 cm
Leeds Museums and Galleries
(Leeds Art Gallery)

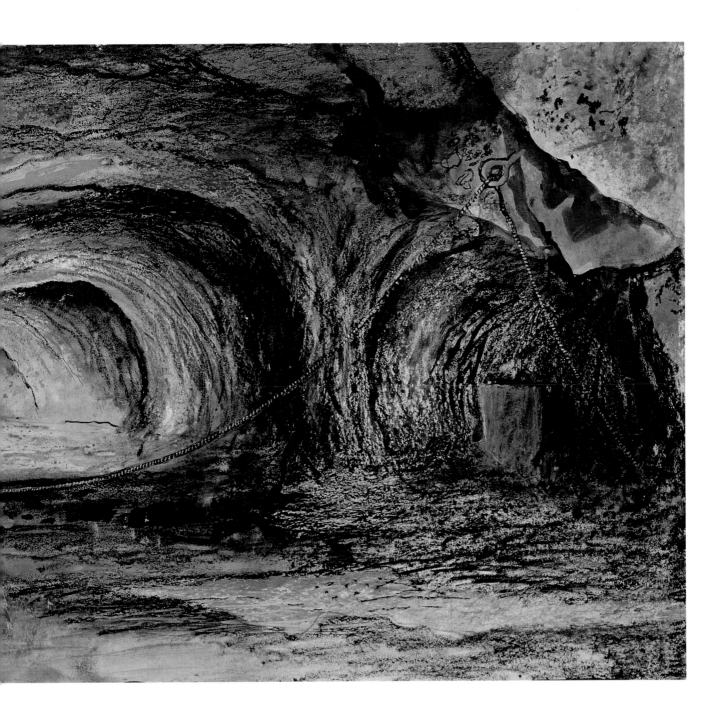

73

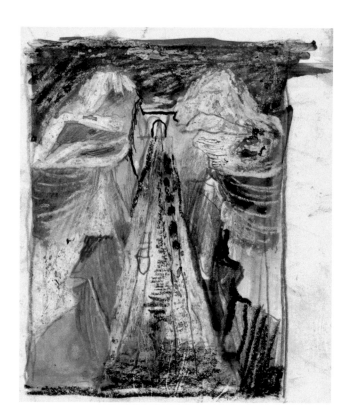 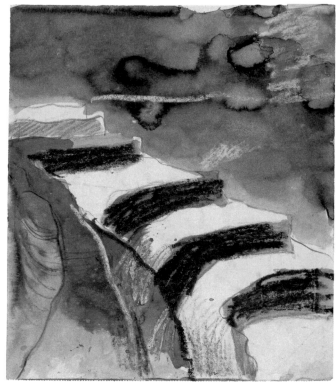

The Quarry Railway 1943
Ink, gouache, pencil and pastel on paper
24.2 × 21.4 cm
Imperial War Museums

Limestone Quarry 1943
Mixed media on paper
23.9 × 21.3 cm
Amgueddfa Cymru –
National Museum Wales

Quarry 1943
Watercolour, gouache
and wax crayon on paper
24.2 × 21 cm
Imperial War Museums

Quarry 1943
Watercolour, gouache,
ink and wax crayon on paper
24 × 21.3 cm
Imperial War Museums

Quarry Railways 1943
Ink, gouache and pencil on paper
24.1 × 21.4 cm
Imperial War Museums

Limestone Quarry 1943
Watercolour, ink, gouache
and pencil on paper
25.2 × 19.2 cm
Imperial War Museums

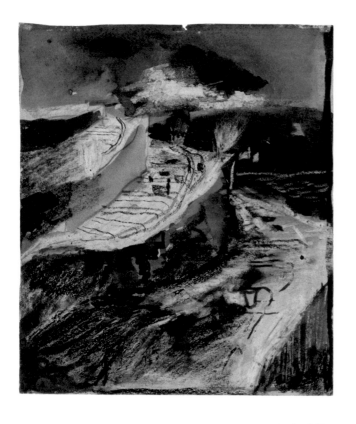 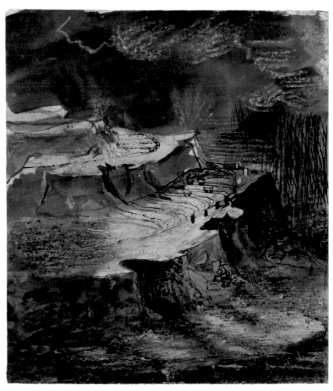

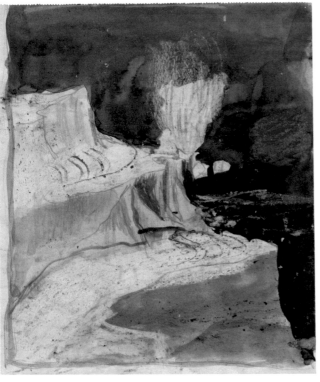 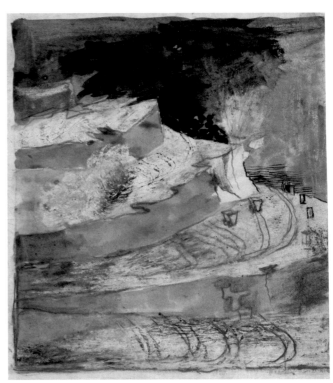

75

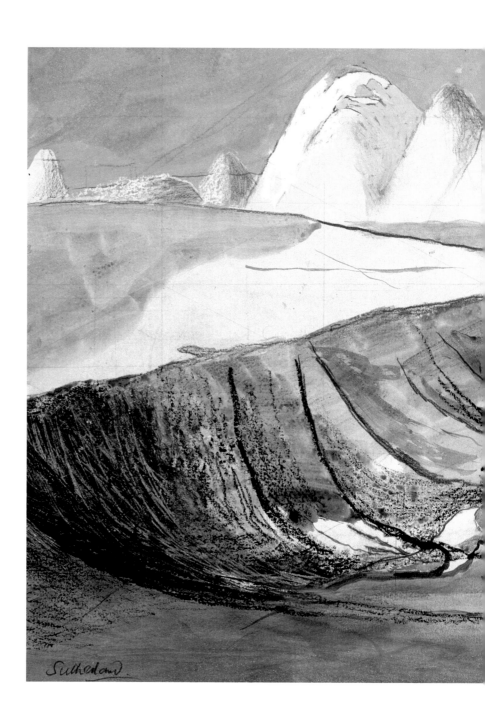

Outcast Coal Production:
Excavators uncovering
a coal seam c.1943
Chalk and gouache on paper
64.6 × 107.2 cm
Leeds Museums and Galleries
(Leeds Art Gallery)

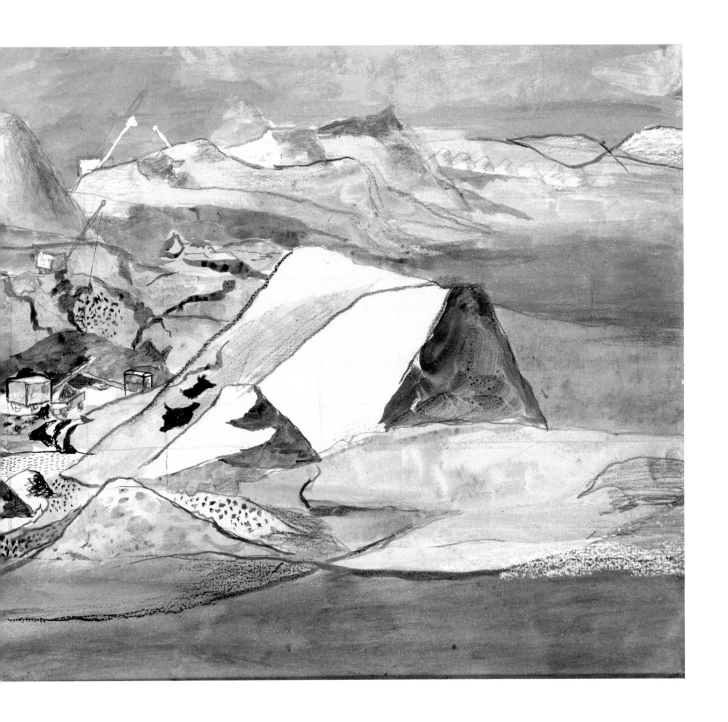

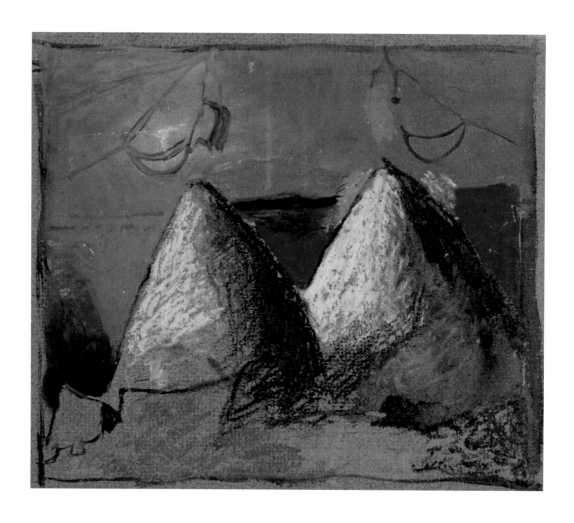

Folded Hills 1945
Gouache and crayon on hardboard
43.5 × 47 cm
Victoria and Albert Museum

Outcast Coal Production:
Dragline depositing
excavated earth 1943
Chalk and gouache on paper
90 × 86.9 cm
Leeds Museums and Galleries
(Leeds Art Gallery)

78

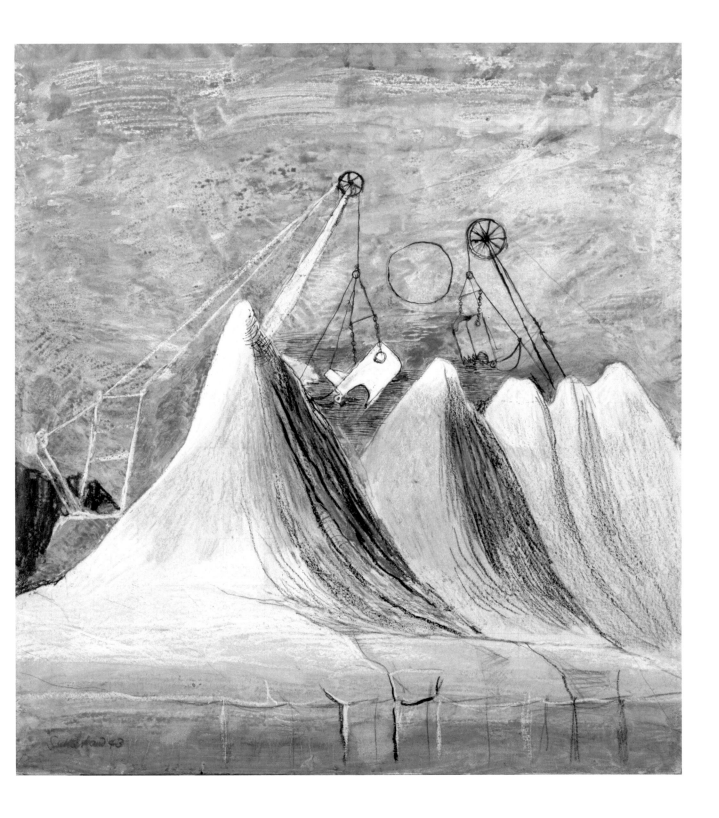

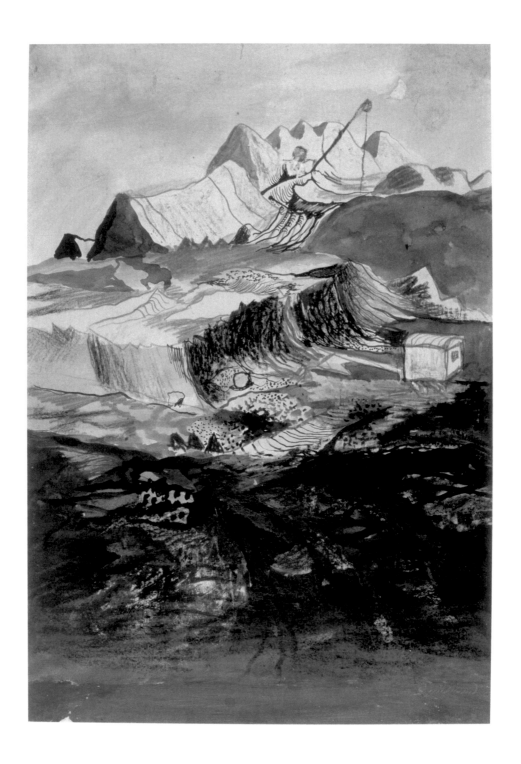

Earth Removed from Coal 1943
Bodycolour, pencil and
watercolour on board
44.5 × 31.8 cm
Laing Art Gallery, Tyne & Wear Archives
& Museums

Moving Back Earth from Coal 1943
Bodycolour, wax crayon,
pencil and watercolour on paper
60.9 × 48.4 cm
Laing Art Gallery, Tyne & Wear Archives
& Museums

80

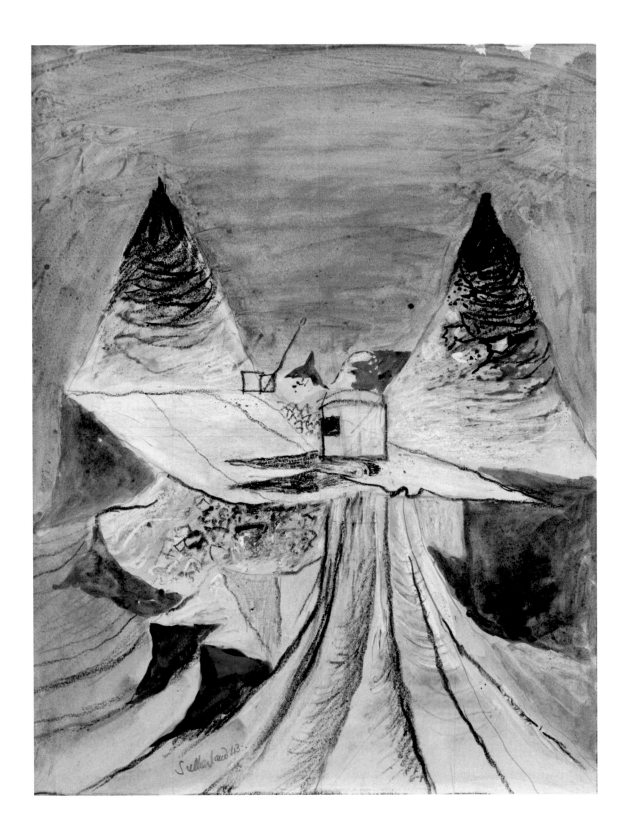

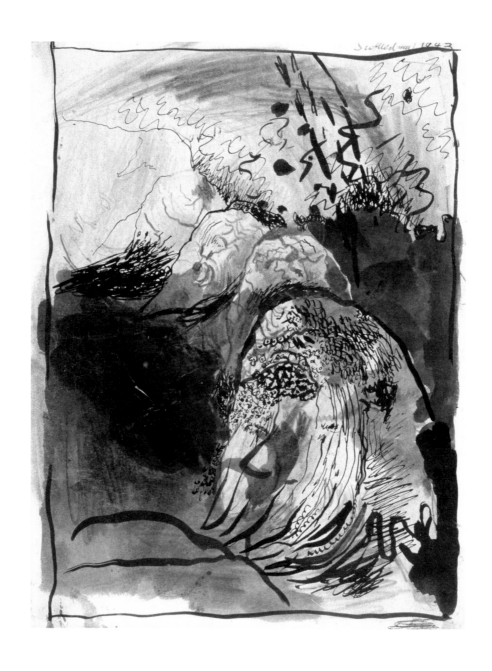

Landscape with mounds 1943
Ink and wash on paper
17.3 × 22.4 cm
Amgueddfa Cymru – National Museum Wales

Study of Rocks undated
Gouache and charcoal on paper
27 × 20.5 cm
Amgueddfa Cymru – National Museum Wales

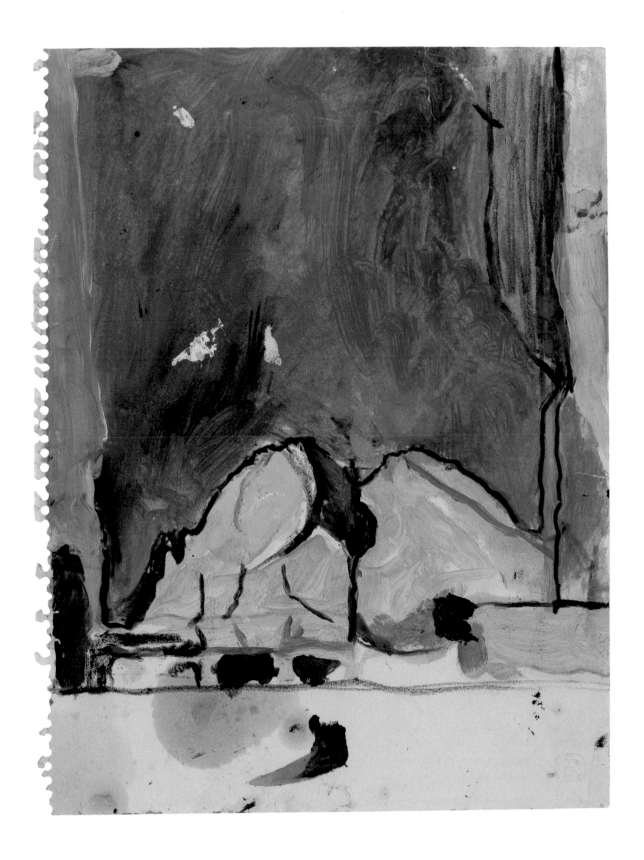

83

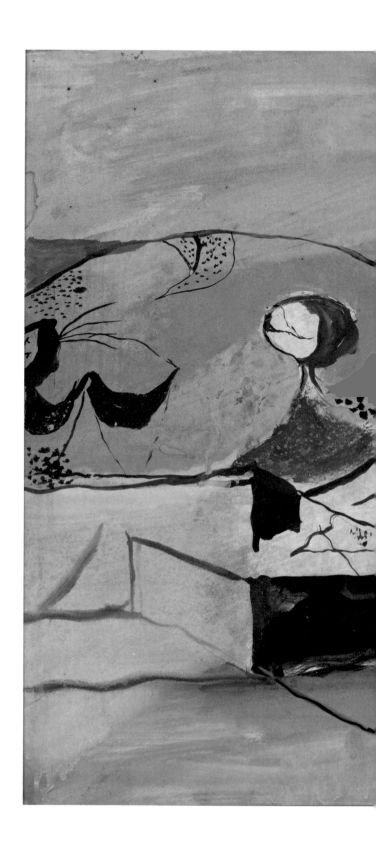

Landscape with Rocks 1944
Gouache on paper laid on hardboard
41.3 × 54 cm
Swindon Museum & Art Gallery

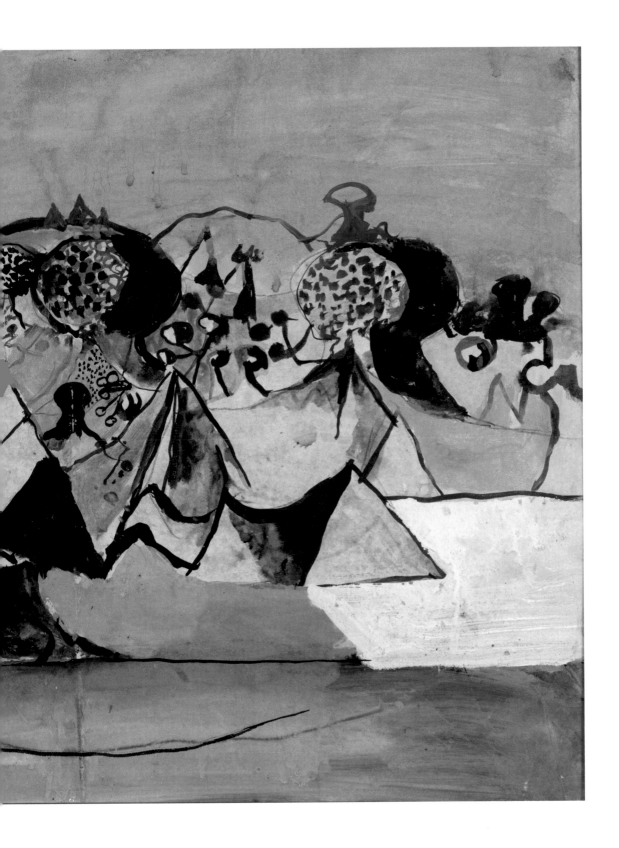

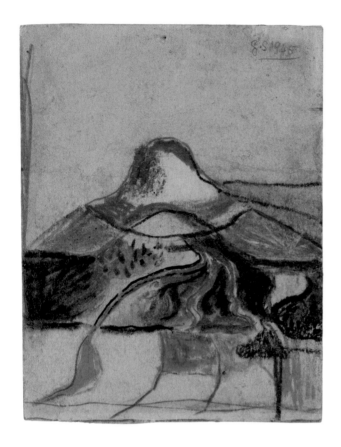 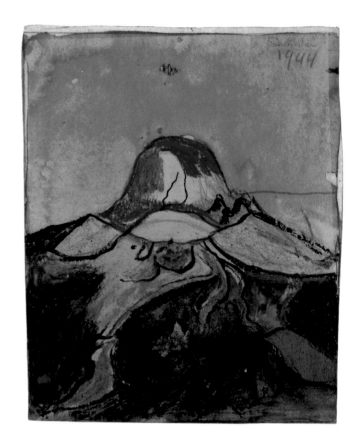

Study for a Mountain 1945
Watercolour, pencil and chalk on paper
22.8 × 17.7 cm
Collection Bernard Jacobson Gallery, London

Mountain & Orange Sky 1944
Watercolour, crayon, charcoal
and ink on paper
22.3 × 18 cm
Pallant House Gallery
(Kearley Bequest through the Art Fund, 1989)

Little Mountain in Wales 1944
Oil on paper
29 × 24 cm
Kirklees Collection
Huddersfield Art Gallery

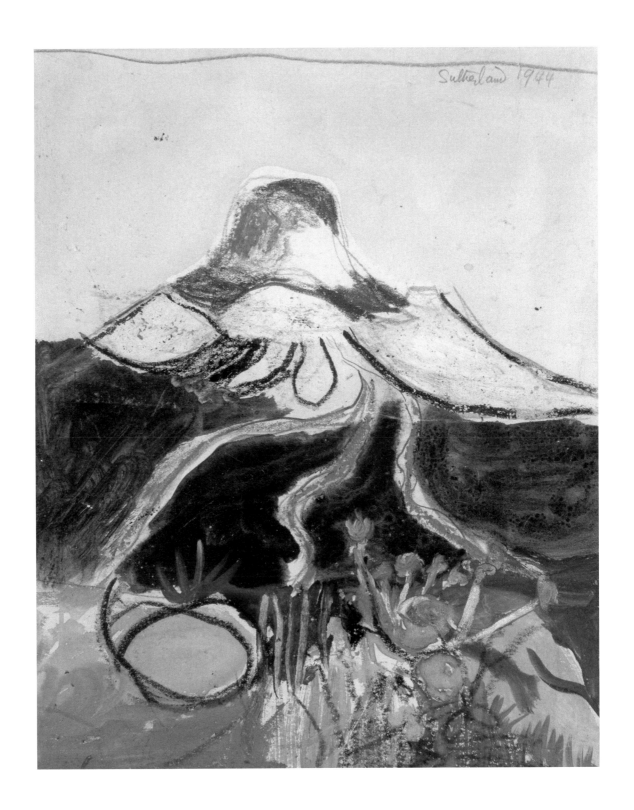

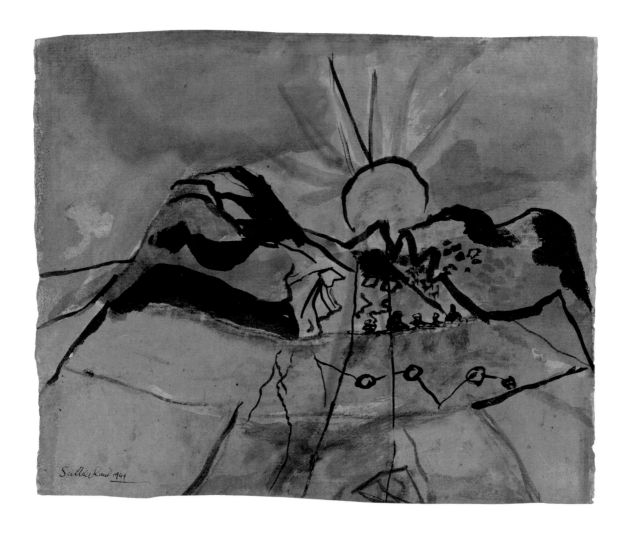

The Setting Sun 1944
Gouache and watercolour on paper
23 × 28.3 cm
British Council Collection

Landscape Study of Cairns 1944
Gouache and pencil on paper
42 × 39.4 cm
Pallant House Gallery
(Kearley Bequest through the Art Fund, 1989)

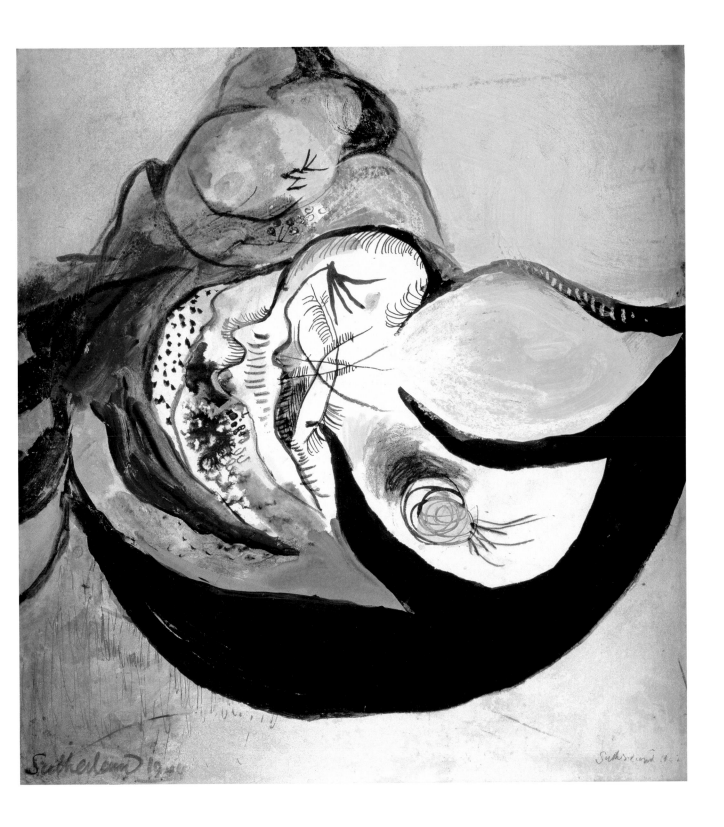

89

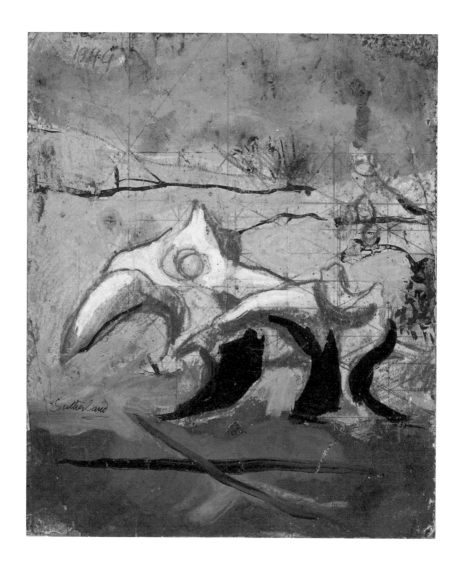

Study for 'Horned Forms' 1944
Gouache on paper
15.9 × 13.3 cm
Tate: Presented by the artist 1971

Plants and Shapes before Hills 1944
Bodycolour on paper
43.3 × 33.1 cm
The Whitworth Art Gallery,
The University of Manchester

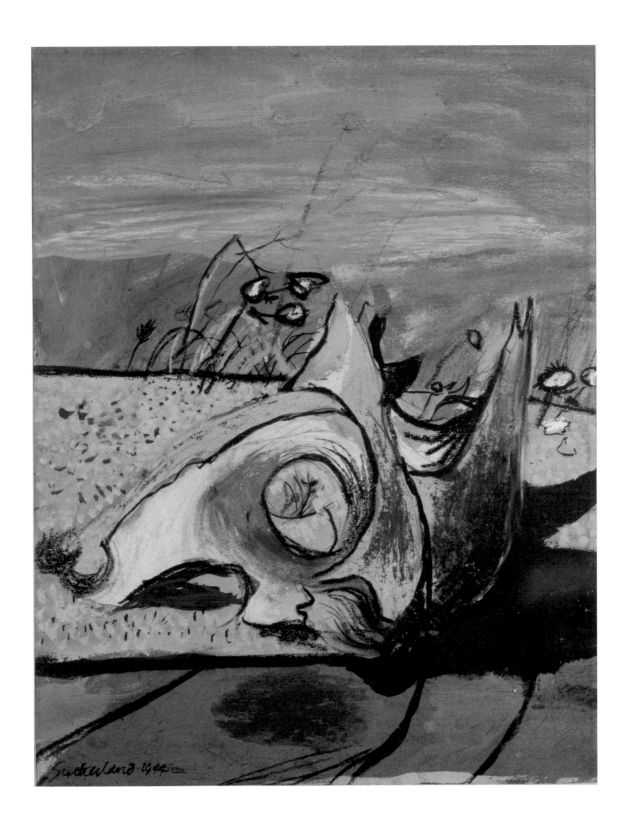

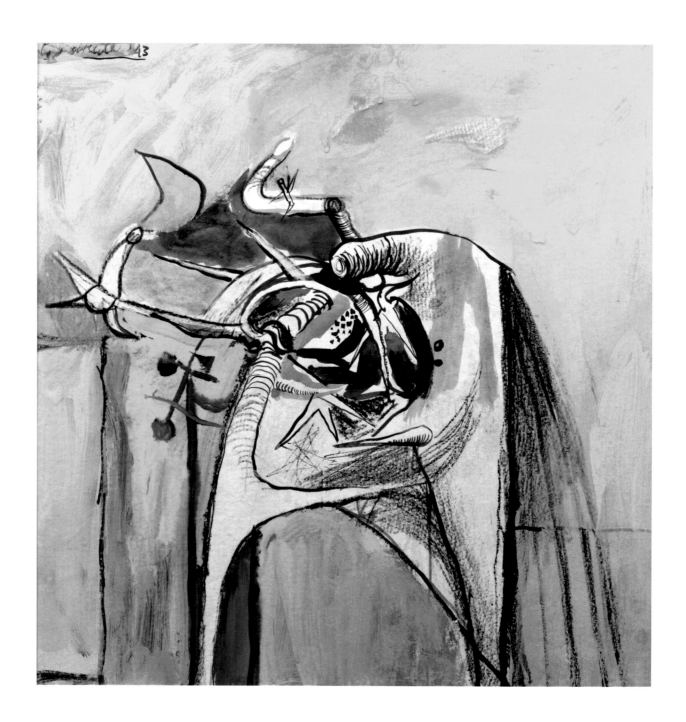

Interlocking Tree Form 1943
Pencil, brush and ink, bodycolour on paper
51.5 × 51.2 cm
The Whitworth Art Gallery,
The University of Manchester

Twisted Tree Form 1944
Pencil, bodycolour and watercolour on board
58.1 × 48.2 cm
Laing Art Gallery, Tyne & Wear Archives
& Museums

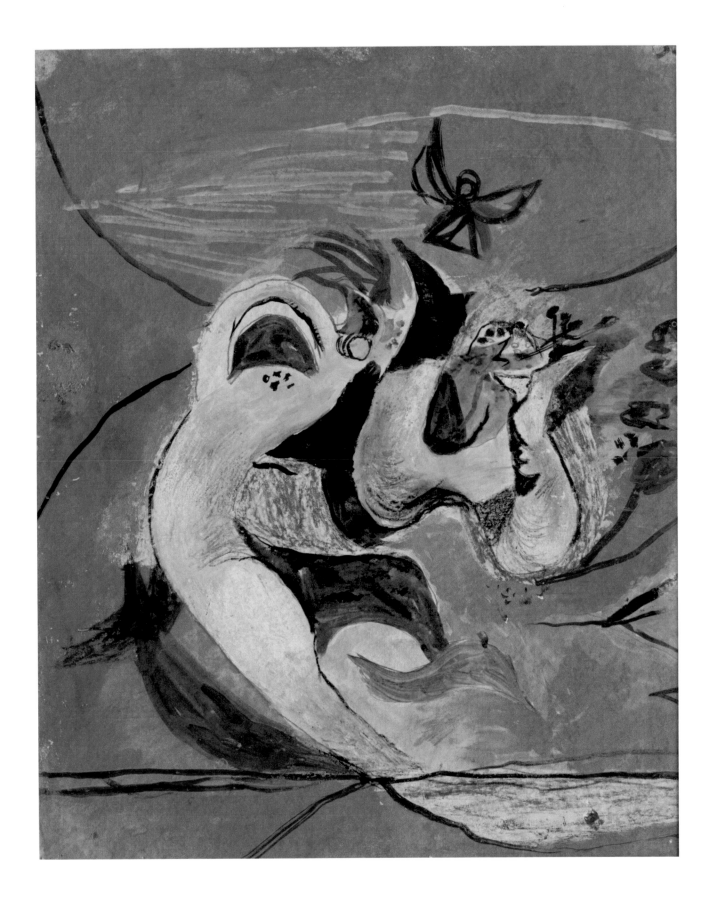

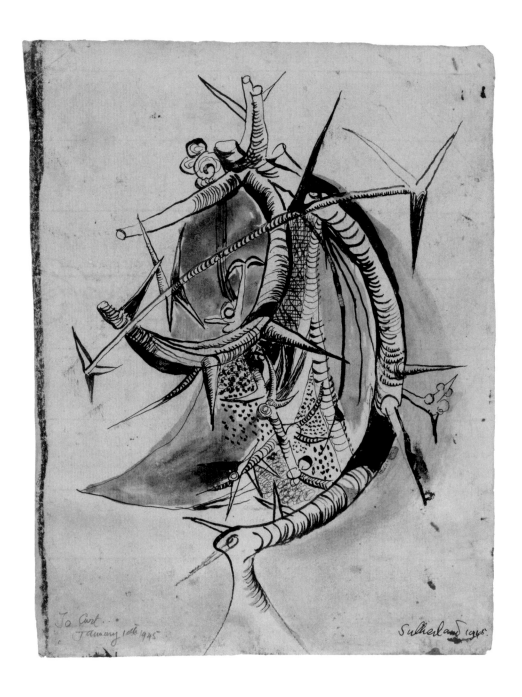

Thorn Head 1945
Indian ink, black crayon, and grey
wash on discoloured laid paper
24.2 × 18.5 cm
Ashmolean Museum, Oxford
Bequeathed by Paul Clark, 2010

Thorns 1945
Watercolour, chalk and ink on paper
41 × 31.5 cm
British Council Collection

94

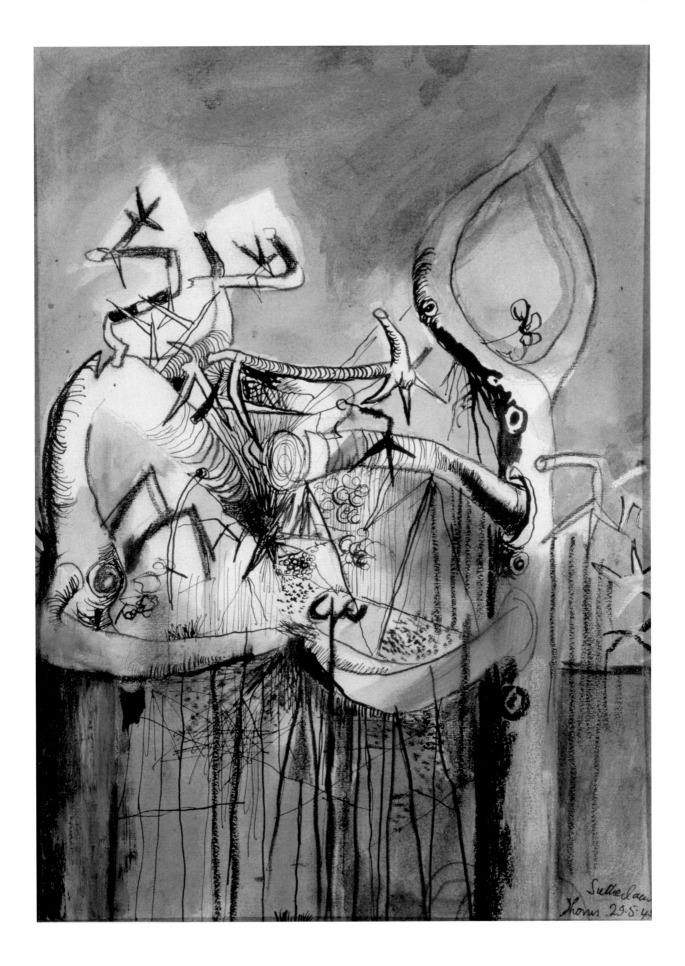

Sutherland
Thorns 29·5·4

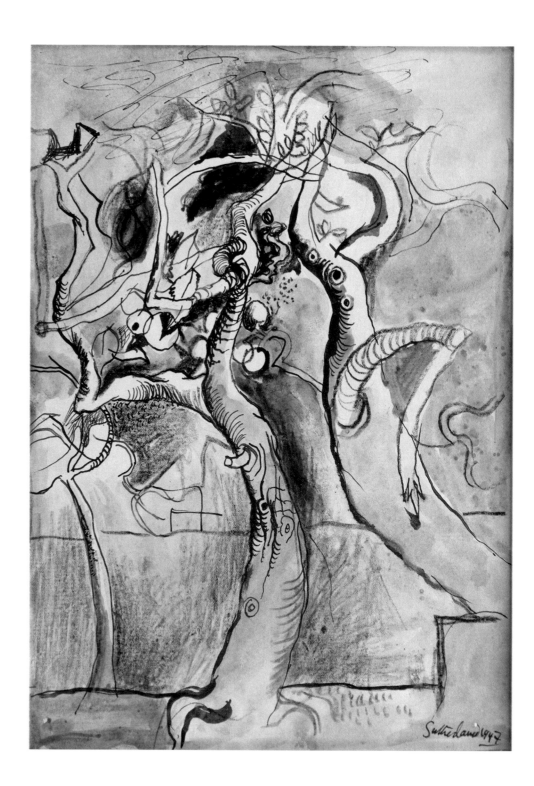

Two Trees 1947
Ink and wash with black
chalk on paper
27.8 × 20.7 cm
Pallant House Gallery
(Hussey Bequest, Chichester
District Council, 1985)

The Thorntree 1946
Bodycolour with ink, pencil
and wax crayon on paper
20.5 × 15.2 cm
Trustees of the Cecil Higgins
Art Gallery, Bedford

96

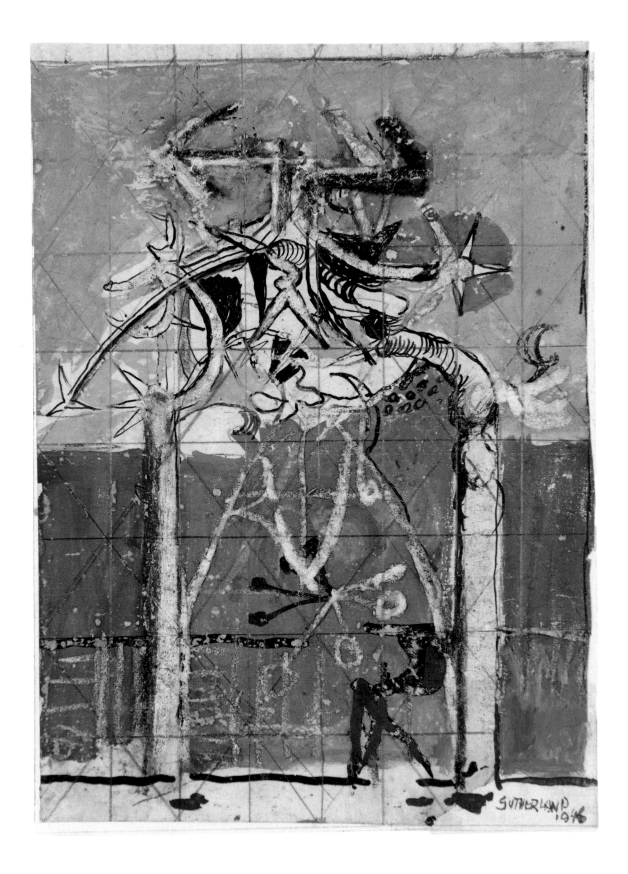

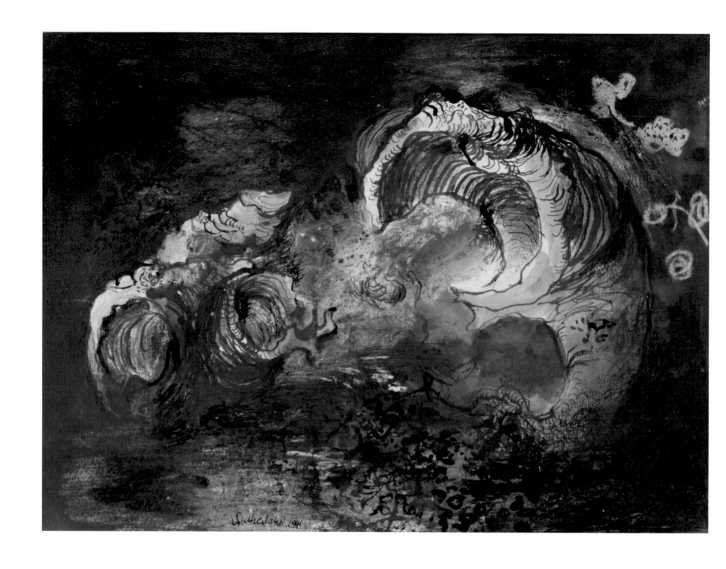

Dwarf Oaks 1941
Coloured chalk, Indian ink
and gouache on paper
25.5 × 35.5 cm
Private Collection

Woods and Estuary 1945
Pen, chalk and gouache on paper
43 × 39 cm
Private Collection

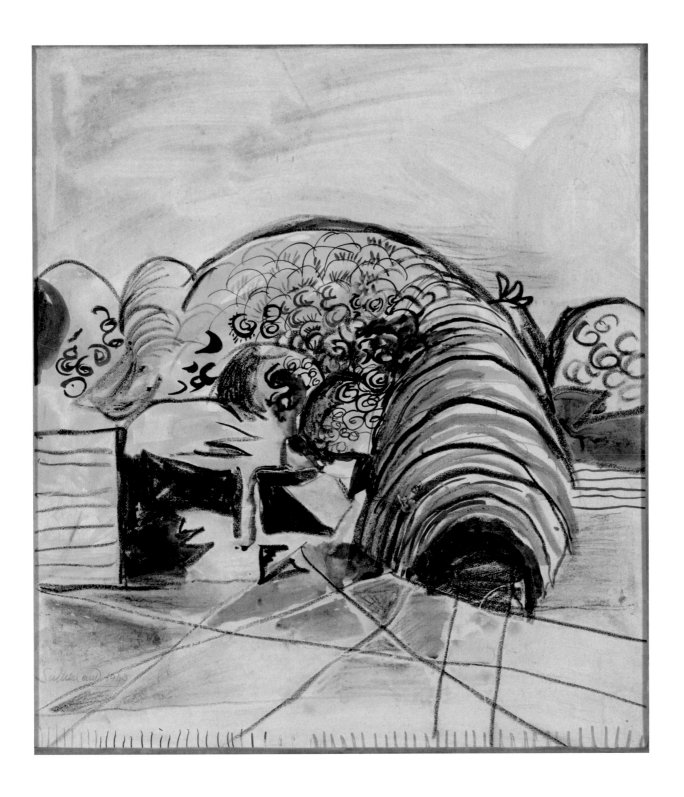

99

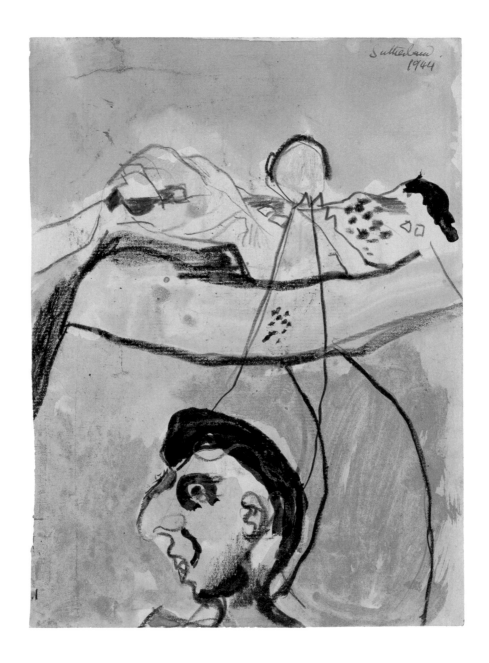

Man & Fields 1944
Mixed media on paper
22.6 × 17.2 cm
Amgueddfa Cymru – National Museum Wales

Road Mounting between Hedges:
Sunrise 1949
Pen, ink, wash and crayon on paper
61 × 46 cm
Presented by the Contemporary
Art Society in 1955
Kirklees Collection

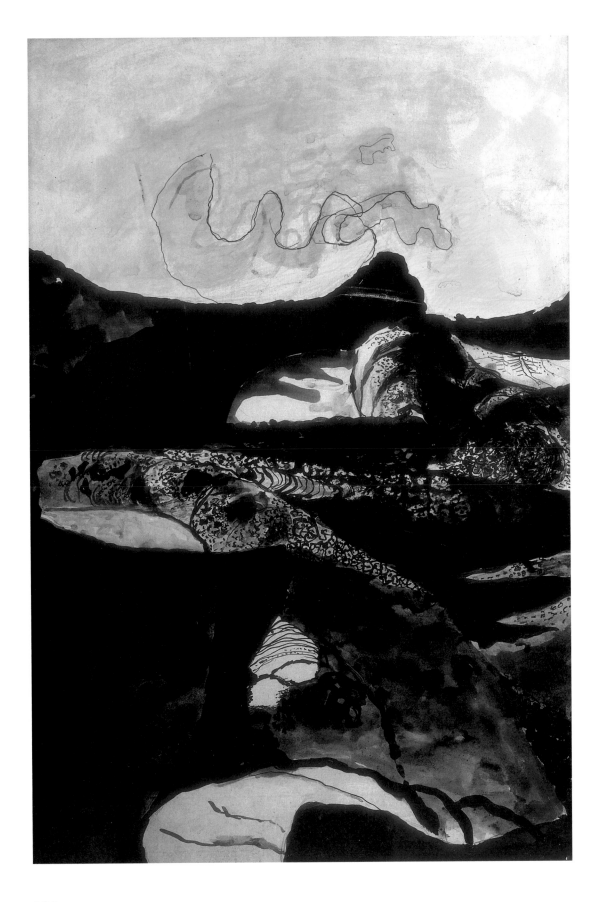

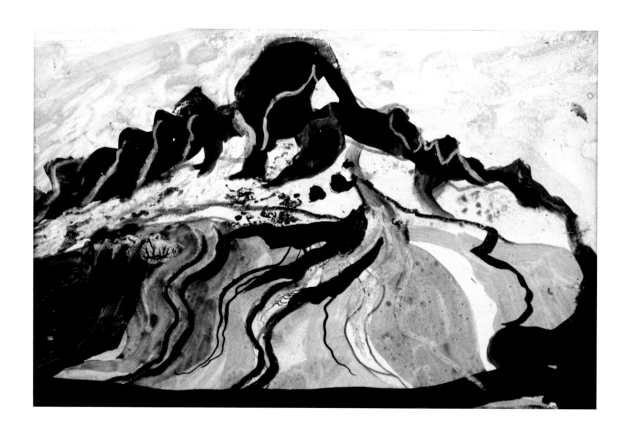

Carn Llidi, Pembroke 1944
Bodycolour on paper
15.2 × 23 cm
The Whitworth Art Gallery,
The University of Manchester

Cornstook in Landscape 1945–46
Pencil, brush & ink, bodycolour on paper
60.3 × 42.6 cm
The Whitworth Art Gallery,
The University of Manchester

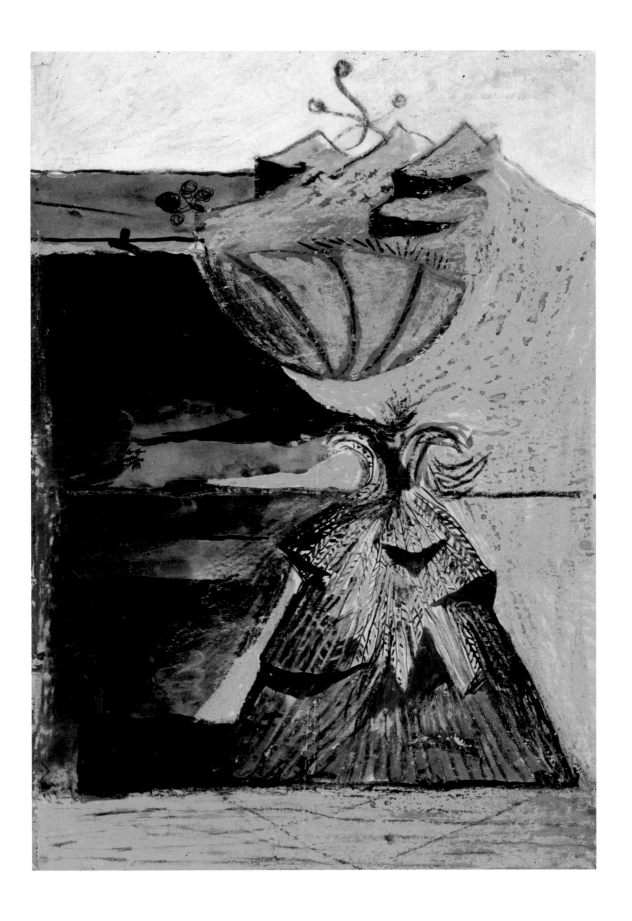

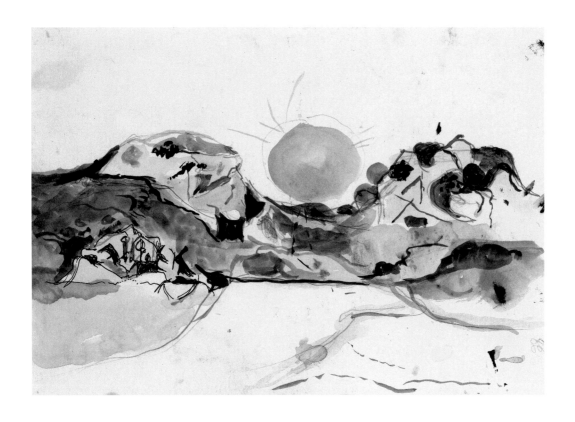

Landscape 1969
Pencil, ink and watercolour on paper
17.5 × 22.5 cm
Harry Moore-Gwyn (Moore-Gwyn Fine Art)

Landscape 1974
Watercolour, ink and gouache on paper
26.5 × 49 cm
Harris Museum & Art Gallery, Preston

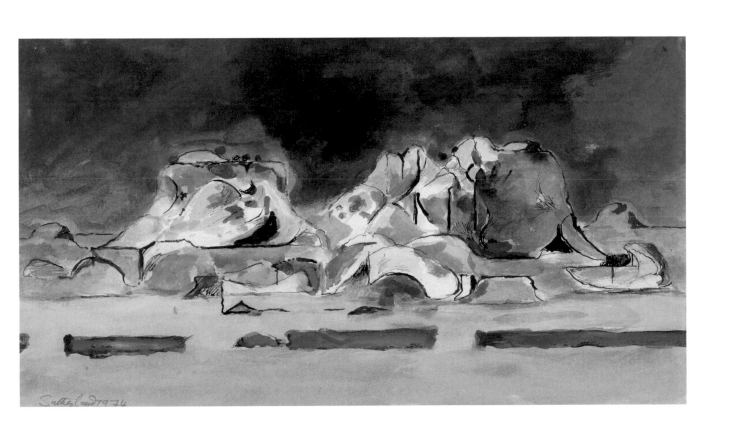

Twisting Roads 1976
Watercolour, gouache, chalk
and pencil on paper
55.5 × 57 cm
Private Collection

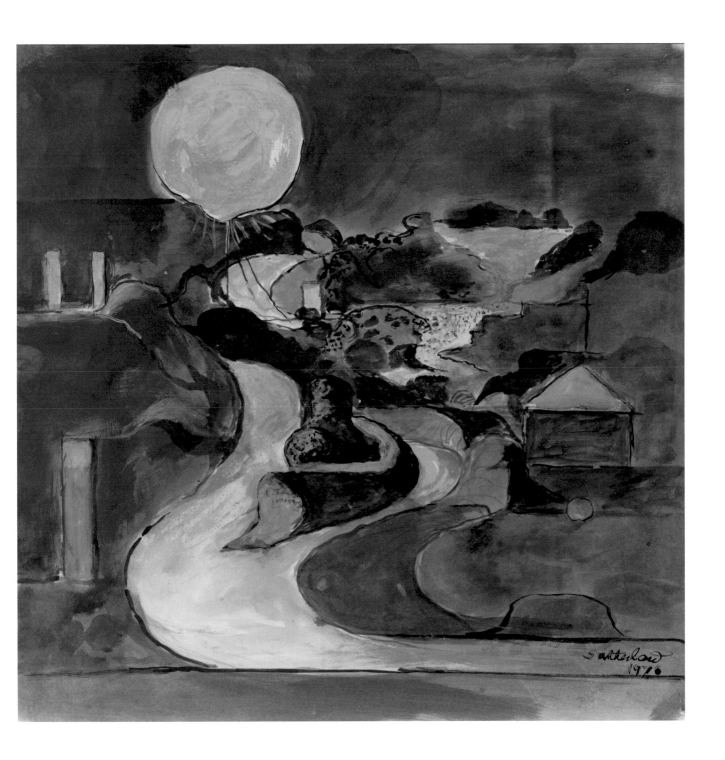

List of Works

Mountain Landscape 1936
Gouache on paper
9.7 × 12.7 cm
Amgueddfa Cymru –
National Museum Wales
(p.30)

Pembrokeshire Landscape
1935
Mixed media on paper
37.8 × 56.7 cm
Amgueddfa Cymru –
National Museum Wales
(p.31)

Sun Setting Between Hills
1937
Watercolour on paper
26.5 × 36 cm
Private Collection
(p.32)

**Welsh Landscape with Yellow
Lane** 1939–40
Watercolour, gouache, black ink,
coloured chalks over pencil on paper
69.5 × 49 cm
Private Collection, London
(p.33)

Rocky Landscape 1940
Indian ink on paper
8 × 10 cm
Private Collection
(p.34)

Welsh Landscape 1936
Gouache on paper
35 × 54.5 cm
Private Collection, London
(p.35)

Study for 'Blasted Tree' 1937
Pen and watercolour on paper
11.5 × 8.5 cm
Private Collection
(p.36)

**Study for 'Midsummer
Landscape'** 1940
Pen and watercolour on paper
10.5 × 8 cm
Private Collection
(p.37)

Study for 'Blasted Oak' 1937
Mixed media on paper
34.1 × 25.9 cm
Amgueddfa Cymru –
National Museum Wales
(p.39)

Study for 'Form in Estuary'
1937
Watercolour, pen and ink,
and pencil on paper
9 × 7 cm
Private Collection
(p.40)

**Study for 'Road mounting
between Hedges'** 1940
Watercolour, pen and ink,
and pencil on paper
9 × 7 cm
Private Collection
(p.40)

Cairn undated
Watercolour, pen and ink on paper
6 × 8 cm
Private Collection
(p.41)

**Study for 'Road mounting
between Hedges'** 1937
Watercolour, pen and ink on paper
9 × 7 cm
Private Collection
(p.41)

**Drawing of Tree Roots
(with squaring)** c.1939
Pencil, ink and watercolour on paper
10.5 × 18.5 cm
Private Collection
(p.42)

Tree Forms in Estuary 1939
Watercolour, gouache and ink on
paper
29 × 22.5 cm
Doncaster Museum Service,
Doncaster Metropolitan Borough
Council
(p.43)

Pembrokeshire Landscape
1939
Pen and ink, with indian ink wash,
white bodycolour and graphite
on card
12 × 18 cm
Ashmolean Museum, Oxford
(p.44)

Gypsy Tent 1939
Mixed media on paper
18.1 × 14.2 cm
Amgueddfa Cymru –
National Museum Wales
(p.45)

**July 9, No.1 of Five Studies
for 'Entrance to a Lane'** 1939
Ink and watercolour on paper
13.2 × 21.5 cm
Pallant House Gallery
(Hussey Bequest, Chichester
District Council, 1985)
(p.46)

**No.5 of Five Studies for
'Entrance to a Lane'** 1939
Ink and watercolour on paper
13.5 × 10.8 cm
Pallant House Gallery
(Hussey Bequest, Chichester
District Council, 1985)
(p.46)

**July 10 3.30-4,
No.2 of Five Studies for
'Entrance to a Lane'** 1939
Ink and watercolour on paper
15.8 × 13.3 cm
Pallant House Gallery
(Hussey Bequest, Chichester
District Council, 1985)
(p.47)

**July 10. 4. 5.30-6,
No.3 of Five Studies for
'Entrance to a Lane'** 1939
Ink and watercolour on paper
16.1 × 13.3 cm
Pallant House Gallery
(Hussey Bequest, Chichester
District Council, 1985)
(p.47)

**July 11.4. 5.30.6,
No.4 of Five Studies for
'Entrance to a Lane'** 1939
Ink and watercolour on paper
15.8 × 13.3 cm
Pallant House Gallery
(Hussey Bequest, Chichester
District Council, 1985)
(p.47)

**Trees Under Mynedd Pen
Cyrm** 1939
Pen and watercolour on paper
29.8 × 22.4 cm
Trustees of the Cecil Higgins
Art Gallery, Bedford
(p.48)

**Dark Hill – Landscape with
Hedges and Fields** 1940
Watercolour and gouache on paper
48.9 × 69.8 cm
Swindon Museum & Art Gallery
(p.49)

The Wanderer 1940
Pencil, watercolour and
conte crayon on artists' board
47 × 61 cm
Victoria and Albert Museum
(p.50)

**Rocky Landscape with Sullen
Sky** 1940
Watercolour and gouache on paper
48 × 69 cm
Harris Museum & Art Gallery, Preston
(p.51)

**Devastation 1940:
Study of a Collapsed Roof**
1940
Pen and black ink
and watercolour on wove
79.5 × 53.5 cm
Manchester City Galleries
Transferred to Manchester City
Galleries by H.M. Government War
Artists' Advisory Committee, 1947
(p.52)

**Devastation 1941:
City Ruined Buildings** 1941
Watercolour, bodycolour
and chalk on paper
32 × 45 cm
Manchester City Galleries
Transferred to Manchester City
Galleries by H.M. Government War
Artists' Advisory Committee, 1947
(p.53)

**Devastation, 1941: East End,
Wrecked Public House** 1941
Crayon, pen and ink, pastel and
gouache on paper
67.3 × 47.6 cm
Tate: Presented by the War Artists
Advisory Committee 1946
(p.54)

**Devastation, 1940:
A House on the Welsh Border**
1940
Watercolour, gouache
and drawing on paper
80 × 54.6 cm
Tate: Presented by the War Artists
Advisory Committee 1946
(p.55)

**Four Studies of Bomb
Damage** 1941
Chalk, ink and pencil on paper
25 × 19.2 cm
Arts Council Collection,
Southbank Centre, London
(p.56)

Twisted Girders, Blitz 1941
Mixed media on paper on card
29.7 × 24.5 cm
Amgueddfa Cymru –
National Museum Wales
(p.57)

Fallen Lift Shaft 1941
Pen and ink, with chalk, wash
and watercolour on paper
57 × 71 cm
Junior Common Room Art Collection.
With permission of the Warden and
Scholars of New College, Oxford
(p.58)

**Devastation or
The City: Twisted Girders** 1941
Wax, ink, gouache, wax crayon,
watercolour and ink wash on paper
80 × 54.3 cm
The Royal Pavilion & Museums,
Brighton & Hove
(p.59)

**Devastation 1941:
City, Twisted Girders** 1941
Gouache, charcoal and ink on paper
55.4 × 112.3 cm
Ferens Art Gallery, Hull Museums
(pp.60/61)

Aberthaw, Cardiff 1940
Mixed media on paper laid down on
board
15.7 × 22.4 cm
Amgueddfa Cymru –
National Museum Wales
(p.62)

A Farmhouse in Wales 1940
Mixed media on paper laid down on
board
16.8 × 25 cm
Amgueddfa Cymru –
National Museum Wales
(p.63)

Debris Study c.1940–41
Mixed media on paper laid down on
board
13.2 × 20.5 cm
Amgueddfa Cymru –
National Museum Wales
(p.64)

Debris Study c.1940–41
Mixed media on paper laid down on
board
14.2 × 10.4 cm
Amgueddfa Cymru –
National Museum Wales
(p.64)

**Cardiff Farmhouse, St. Mary
Church** c.1940
Mixed media on paper
laid down on board
23.5 × 30.6 cm
Amgueddfa Cymru –
National Museum Wales
(p.65)

Bomb Damage Swansea 1940
Watercolour and gouache on paper
38.7 × 27.9 cm
The Potteries Museum and Art Gallery,
Stoke-on-Trent
(p.66)

**Devastation 1941:
City Panorama** 1941
Ink, crayon and gouache on paper
30.3 × 44.8 cm
Pallant House Gallery
(Kearley Bequest, 1989)
(p.67)

**Devastation, 1941: East End,
Burnt Paper Warehouse** 1941
Gouache, pastel, pencil and pen
and ink on paper, mounted on card
67.3 × 113.7 cm
Tate: Presented by the War Artists
Advisory Committee 1946
(pp.68/69)

Side of Pit scaled by Dragline
1943
Brush and black ink, black chalk,
soft graphite, pastel and watercolour
42.2 × 30.2 cm
Ashmolean Museum, Oxford
Presented by H.M. Government (War
Artists' Advisory Committee), 1947
(p.70)

Limestone Kilns and Quarries
1943
Chalk, indian ink, wax crayon,
watercolour and ink wash on paper
66 × 57.7 cm
The Royal Pavilion & Museums,
Brighton & Hove
(p.71)

Tin Mine: A Declivity c.1942
Pen, chalk and watercolour on paper,
mounted on board
63.5 × 109.5 cm
Leeds Museums and Galleries
(Leeds Art Gallery)
(pp.72/73)

The Quarry Railway 1943
Ink, gouache, pencil and
pastel on paper
24.2 × 21.4 cm
Imperial War Museums
(p.74)

Limestone Quarry 1943
Mixed media on paper
23.9 × 21.3 cm
Amgueddfa Cymru –
National Museum Wales
(p.74)

Quarry 1943
Watercolour, gouache
and wax crayon on paper
24.2 × 21 cm
Imperial War Museums
(p.75)

Quarry 1943
Watercolour, gouache,
ink and wax crayon on paper
24 × 21.3 cm
Imperial War Museums
(p.75)

Quarry Railways 1943
Ink, gouache and pencil on paper
24.1 × 21.4 cm
Imperial War Museums
(p.75)

Limestone Quarry 1943
Watercolour, ink, gouache
and pencil on paper
25.2 × 19.2 cm
Imperial War Museums
(p.75)

**Outcast Coal Production:
Excavators uncovering
a coal seam** c.1943
Chalk and gouache on paper
64.6 × 107.2 cm
Leeds Museums and Galleries
(Leeds Art Gallery)
(pp.76/77)

Folded Hills 1945
Gouache and crayon on hardboard
43.5 × 47 cm
Victoria and Albert Museum
(p.78)

**Outcast Coal Production:
Dragline depositing
excavated earth** 1943
Chalk and gouache on paper
90 × 86.9 cm
Leeds Museums and Galleries
(Leeds Art Gallery)
(p.79)

Earth Removed from Coal
1943
Bodycolour, pencil and
watercolour on board
44.5 × 31.8 cm
Laing Art Gallery, Tyne &
Wear Archives & Museums
(p.80)

Moving Back Earth from Coal
1943
Bodycolour, wax crayon,
pencil and watercolour on paper
60.9 × 48.4 cm
Laing Art Gallery, Tyne &
Wear Archives & Museums
(p.81)

Landscape with mounds 1943
Ink and wash on paper
17.3 × 22.4 cm
Amgueddfa Cymru –
National Museum Wales
(p.82)

Study of Rocks undated
Gouache and charcoal on paper
27 × 20.5 cm
Amgueddfa Cymru –
National Museum Wales
(p.83)

Landscape with Rocks 1944
Gouache on paper laid on hardboard
41.3 × 54 cm
Swindon Museum & Art Gallery
(pp.84/85)

Study for a Mountain 1945
Watercolour, pencil and chalk
on paper
22.8 × 17.7 cm
Collection Bernard Jacobson Gallery,
London
(p.86)

Mountain & Orange Sky 1944
Watercolour, crayon, charcoal
and ink on paper
22.3 × 18 cm
Pallant House Gallery (Kearley
Bequest through the Art Fund, 1989)
(p.86)

Little Mountain in Wales 1944
Oil on paper
29 × 24 cm
Kirklees Collection
Huddersfield Art Gallery
(p.87)

The Setting Sun 1944
Gouache and watercolour on paper
23 × 28.3 cm
British Council Collection
(p.88)

Landscape Study of Cairns
1944
Gouache and pencil on paper
42 × 39.4 cm
Pallant House Gallery (Kearley
Bequest through the Art Fund, 1989)
(p.89)

Study for 'Horned Forms' 1944
Gouache on paper
15.9 × 13.3 cm
Tate: Presented by the artist 1971
(p.90)

**Plants and Shapes before
Hills** 1944
Bodycolour on paper
43.3 × 33.1 cm
The Whitworth Art Gallery,
The University of Manchester
(p.91)

Interlocking Tree Form 1943
Pencil, brush and ink,
bodycolour on paper
51.5 × 51.2 cm
The Whitworth Art Gallery,
The University of Manchester
(p.92)

Twisted Tree Form 1944
Pencil, bodycolour and
watercolour on board
58.1 × 48.2 cm
Laing Art Gallery, Tyne &
Wear Archives & Museums
(p.93)

Thorn Head 1945
Indian ink, black crayon, and grey
wash on discoloured laid paper
24.2 × 18.5 cm
Ashmolean Museum, Oxford
Bequeathed by Paul Clark, 2010
(p.94)

Thorns 1945
Watercolour, chalk and ink on paper
41 × 31.5 cm
British Council Collection
(p.95)

Two Trees 1947
Ink and wash with black
chalk on paper
27.8 × 20.7 cm
Pallant House Gallery
(Hussey Bequest, Chichester
District Council, 1985)
(p.96)

The Thorntree 1946
Bodycolour with ink, pencil
and wax crayon on paper
20.5 × 15.2 cm
Trustees of the Cecil Higgins
Art Gallery, Bedford
(p.97)

Dwarf Oaks 1941
Coloured chalk, Indian ink
and gouache on paper
25.5 × 35.5 cm
Private Collection
(p.98)

Woods and Estuary 1945
Pen, chalk and gouache on paper
43 × 39 cm
Private Collection
(p.99)

Man & Fields 1944
Mixed media on paper
22.6 × 17.2 cm
Amgueddfa Cymru –
National Museum Wales
(p.100)

**Road Mounting between
Hedges: Sunrise** 1949
Pen, ink, wash and crayon on paper
61 × 46 cm
Presented by the Contemporary
Art Society in 1955
Kirklees Collection
(p.101)

Carn Llidi, Pembroke 1944
Bodycolour on paper
15.2 × 23 cm
The Whitworth Art Gallery,
The University of Manchester
(p.102)

Cornstook in Landscape
1945–46
Pencil, brush & ink, bodycolour
on paper
60.3 × 42.6 cm
The Whitworth Art Gallery,
The University of Manchester
(p.103)

Landscape 1969
Pencil, ink and watercolour
on paper
17.5 × 22.5 cm
Harry Moore-Gwyn
(Moore-Gwyn Fine Art)
(p.104)

Landscape 1974
Watercolour, ink and gouache
on paper
26.5 × 49 cm
Harris Museum & Art Gallery, Preston
(p.105)

Twisting Roads 1976
Watercolour, gouache, chalk
and pencil on paper
55.5 × 57 cm
Private Collection
(p.107)

Rachel Flynn

Graham Vivian Sutherland was a painter, printmaker and designer who brought together the richness of the English Romantic tradition with the innovations of modern European art. In his lifetime he was widely regarded as the outstanding painter of his generation.

Born on 24 August 1903, he was raised in London and in Surrey. At the age of 16 he was employed as an apprentice at the Midland Railway Locomotive Works in Derby. Here, he trained as an engineer but displayed no aptitude for mathematics, and after a year's employment, which he later credited with stimulating his lasting fascination with machinery, he enrolled at art school.

Between 1921 and 1926 Sutherland studied at Goldsmiths College, London, where he specialised in etching and developed an enthusiasm for the nineteenth-century Romantic artist Samuel Palmer, producing prints inspired by Palmer's pastoral visions of Kent. In 1926 he converted to Catholicism, and the following year he married Kathleen Frances Barry, who was also a student at Goldsmiths, and the couple moved to a village in Kent. Alongside printmaking, Sutherland started teaching art and designing ceramics, glass and commercial posters. However, after the Wall Street Crash in 1929, the once-thriving prints market collapsed and as a consequence, Sutherland turned to painting.

He first visited Pembrokeshire, Wales, in 1934 and returned regularly over the next decade. This encounter with the Welsh landscape was crucial to the development of his practice. He believed that: 'It was in this country that I began to learn painting ... the clear, yet intricate construction of the landscape coupled with an emotional feeling of being on the brink of some drama, taught me a lesson and had an unmistakable message that has

influenced me profoundly.'[1] Sutherland wandered through the Welsh landscape discovering unexpected places and evocative forms. He was exhilarated by the 'exultant strangeness' he perceived in the 'twisted gorse on the cliff edge … the flowers and damp hollows … the deep green valleys and the rounded hills'.[2]

However, even while he immersed himself in this remote landscape, he was keenly aware of the artistic innovations happening elsewhere in Europe. He admired the work of artists such as Pablo Picasso, Henri Matisse and Joan Miró and felt that they set a challenge that he must respond to in his own practice. It was at this time that Sutherland developed his distinctive approach to art. He believed that drawing on both the English tradition and on modern European art could produce original work. Although he exhibited at the *International Surrealist Exhibition* in London in 1936 and was considered by many to be a leader of the loosely-defined Neo-Romantic movement – alongside other artists such as John Craxton, Paul Nash, John Piper and Eric Ravilious – he resisted artistic labels and groups.

Following the outbreak of the Second World War, Sutherland was appointed Official War Artist by his friend and patron Kenneth Clark, then Director of the National Gallery. He recorded war work at mines, steel works and quarries in Cornwall, South Wales and Derbyshire, and the devastation of bomb-damaged Cardiff, Swansea, London and northern France.

Sutherland first visited southern France in 1947. He recalled: 'To see Provence for the first time is to know Cézanne properly, and the painting of Van Gogh had suddenly for me a new excitement.'[3] He met Picasso and Matisse, gambled with Francis Bacon at a casino in Monte Carlo and in 1955 bought a hillside villa in

Menton. His interest in natural forms, which previously had been fired by gnarled oak trees, twisted gorse and thorn clusters, found new material for scrutiny in the palms, gourds and insects of the Mediterranean.

In France, Sutherland met the writer William Somerset Maugham who in 1949 became the first subject of many portraits by the artist. The media tycoon Lord Beaverbrook exclaimed on seeing his own portrait by Sutherland: 'It's an outrage, but it's a masterpiece!'[4] Conversely, Winston Churchill, his most famous subject, so disliked his portrait that he had it removed from display soon after its unveiling. Years later it was revealed that Churchill's wife, Lady Churchill, had quickly destroyed it.

By the early 1950s, Sutherland was at the peak of his critical and popular acclaim and was engaged in high-profile commissions and exhibitions. In 1951 he contributed a large mural, *The Origins of the Land*, to the Festival of Britain, and in 1952 he represented Britain at the Venice Biennale. A newspaper review of a retrospective at the Tate Gallery the following year claimed: 'When men want to know what it was like living in 1953 they will come to look at the paintings of Graham Sutherland.'[5] Also in 1951, he was asked to design a large tapestry for Coventry Cathedral, which was being rebuilt after being bombed during the Second World War, a labour that would occupy him for the next decade and which would raise his profile still higher. However, this was also a time of mixed fortunes. Having become a Trustee of the Tate in 1948, he controversially resigned in 1954 over the issue of John Rothenstein's directorship. While his popular fame in Britain soared, his critical reputation began a steady decline.

Sutherland was, however, gaining a new audience and important new patrons in France and particularly in Italy. From 1952

he took summer holidays in Venice and for some of that time rented a studio in a former boathouse – the dilapidated and shady interior of which became the setting of a series of paintings. In 1960, back home in Britain, he was awarded the Order of Merit, an honour that Herbert Read, the writer and critic, saw as a symbol of the canonisation of modern art.

In 1967, after an absence of over 20 years, Sutherland returned to Wales to make a film about his early work, and was struck afresh by the country. He again began to work in Pembrokeshire, soaking himself in 'the curiously charged atmosphere – at once both calm and exciting',[6] and returned regularly, visiting for the last time in January 1980, shortly before his death in London on 17 February of that year. Sutherland's work, for many years critically neglected, is now receiving renewed attention. His sensitive, evocative and expressive approach to nature has surely earned him a place among our greatest modern British artists.

1 Graham Sutherland, 'Welsh Sketch Book', *Horizon*, Vol. V, No.28 (April 1942), p.234
2 Ibid.
3 Graham Sutherland quoted in Noël Barber, *Conversations with Painters*, Collins, London, 1964, p.49
4 Lord Beaverbrook quoted in, Roger Berthoud, *Graham Sutherland: A Biography,* Faber & Faber, London, 1982, p.151
5 Bernard Denvir, 'Atom Age Artist', *Daily Herald*, 19 May 1953
6 Graham Sutherland, *Sutherland in Wales: A Catalogue of the Collection at the Graham Sutherland Gallery*, Alistair McAlpine, London, 1976, p.6

Published on the occasion of the exhibition:

Graham Sutherland
An Unfinished World
Modern Art Oxford
10 December 2011 – 18 March 2012
Curated by George Shaw
Assisted by Emily Smith and
Michael Stanley
Installation by Paul Teigh

Edited by Emily Smith and Michael Stanley
Copy Editor: Eileen Daly
Design: Peter Willberg
Printed by: DeckersSnoeck,
in an edition of 2,000

Published by Modern Art Oxford
30 Pembroke Street
Oxford OX1 1BP, UK
Tel. +44 (0)1865 722733
www.modernartoxford.org.uk

© Modern Art Oxford, and the authors, 2011

Distribution UK & Europe:
Cornerhouse Publications
70 Oxford Street
Manchester M1 5NH, UK
Tel: +44 (0) 161 2001503
publications@cornerhouse.org

ISBN 978-1-901352-53-5

Graham Sutherland: An Unfinished World
is supported by Bonhams.

Modern Art Oxford is supported
by Oxford City Council and
Arts Council England.
Museum of Modern Art.
Registered charity no. 313035

MODERN ART OXFORD

OXFORD
CITY
COUNCIL

Supported by
ARTS COUNCIL
ENGLAND

Graham Sutherland Exhibition Circle

Lenders:
Amgueddfa Cymru - National Museum Wales;
Arts Council Collection, Southbank Centre, London;
Ashmolean Museum of Art and Archaeology,
University of Oxford; Bernard Jacobson Gallery,
London; The Royal Pavilion & Museums, Brighton
& Hove; British Council Collection; Cecil Higgins
Art Gallery, Bedford; Doncaster Museum Service,
Doncaster Metropolitan Borough Council; Ferens
Art Gallery, Hull Museums; Harris Museum and Art
Gallery, Preston; Harry Moore-Gwyn, Moore-Gwyn
Fine Art; Imperial War Museums; Kirklees Museums
and Galleries; Laing Art Gallery, Tyne & Wear Archives
& Museums; Leeds Museums and Galleries (Leeds
Art Gallery); Manchester City Galleries; New
College, Oxford; Pallant House Gallery, Chichester;
The Potteries Museum & Art Gallery, Stoke-on-Trent;
Swindon Museum & Art Gallery; Tate; Victoria and
Albert Museum; The Whitworth Art Gallery, The
University of Manchester; and other private lenders
who wish to remain anonymous.

Acknowledgements:
Jill Constantine and Caroline Douglas at Arts
Council Collection; Christina Chilcott, Alexandra
Greathead and Agnes Valencak at the Ashmolean
Museum; Robert Delaney at Bernard Jacobson
Gallery; Jenny Lund at The Royal Pavilion &
Museums; Sinta Berry and Diana Eccles at the
British Council; Victoria Partridge and Tom Perrett
at Cecil Higgins Art Gallery; Neil McGregor at
Doncaster Museum & Art Gallery; Kirsten Simister
at Ferens Art Gallery; Lindsey McCormick at Harris
Museum and Art Gallery; Harry Moore-Gwyn at
Moore-Gwyn Fine Art; Sara Bevan and Jessica
Stewart at Imperial War Museums; Andrew
Charlesworth and Grant Scanlan at Kirklees
Museums and Galleries; Julie Milne and Sarah
Richardson at Laing Art Gallery; Rebecca Herman
and Nigel Walsh at Leeds Art Gallery; Dr Maria
Balshaw, Siân Millar and Hannah Williamson at
Manchester Art Gallery; David Anderson, Rachel
Flynn, Beth McIntyre, Clare Smith and Charlotte
Topsfield at National Museum Wales; Michael
Burden and Jacqui Julier at New College, Oxford;
Simon Martin at Pallant House Gallery; Jean Milton
at The Potteries Museum & Art Gallery; Barbara
Dixon and Paul Ricketts at Swindon Museum & Art
Gallery; Fay Blanchard, Caroline Collier, Rosie
Freemantle and Andrew Wilson at Tate; Alanna
Davidson, David Packer and Rebecca Wallace at the
Victoria and Albert Museum; Dr Maria Balshaw,
David Morris, Gillian Smithson, Helen Stalker and
Phyllis Stoddart at The Whitworth Art Gallery.

We would also like to thank Matthew Bradbury,
Lizzie Hill and Sidonie Metherell at Bonhams;
Michael Bracewell; Victoria White at Cadogan Tate;
Philip Harley, Clare McKeon and Megan Pockley at
Christies; Jack Eden; Colin Harrison; Martin Roberts
at Herbert Art Gallery and Museum, Coventry; David
Fraser Jenkins; Dr Robert Karrer; James Kirkham;
Marcus Leith; Peter Nahum; Melanie Pocock;
Matthew Retallick; John Rolfe; Aarti Chanrai and
James Rawlin at Sothebys; and Clare Woods.

With special thanks to Henry Channon, and Marie
and Emmanuel Moatti.

Photographic credits:
All images of work by Graham Sutherland ©
The Estate of Graham Sutherland; pp.30, 31, 39, 57,
62, 63, 65, 74, 82, 83, 100: National Museum Wales;
pp.32, 34, 35, 36, 37, 40, 41, 42, 45, 86, 98, 99, 107:
Photography by Marcus Leith; p.43: Doncaster
Museum Service, D.M.B.C; p.42, 70, 94 : Ashmolean
Museum, Oxford; pp.46, 47, 67, 86, 96: Pallant House
Gallery (p.89: The Bridgeman Art Library); p.48, 97:
Cecil Higgins Art Gallery & Bedford Museum; p.49:
Swindon Museum & Art Gallery (p.84: Photography
Marcus Leith); pp.50, 78: Victoria and Albert
Museum, London, UK; pp.51, 105: Harris Museum
& Art Gallery, Preston; pp.52, 53: Manchester City
Galleries; pp.54, 55, 68, 90: Tate, London 2011; p.56:
Arts Council Collection, Southbank Centre, London;
p.58: New College, Oxford; p.59, 71: The Royal
Pavilion & Museums, Brighton & Hove; p.60: Ferens
Art Gallery, Hull Museums, UK; p.66: The Potteries
Museum and Art Gallery, Stoke-on-Trent, UK / The
Bridgeman Art Library; pp.76, 79: Leeds Museums
and Galleries (Leeds Art Gallery), (p.72: The
Bridgeman Art Library); pp.74, 75: Imperial War
Museums; pp.80, 81, 93: Laing Art Gallery, Tyne &
Wear Archives & Museums; pp.87, 101: Kirklees
Museums and Galleries; pp.88, 95: British Council;
pp.91, 92, 02, 103: The Whitworth Art Gallery,
The University of Manchester; p.104: Moore-Gwyn
Fine Art

Quotation credits:
p.8 *Jill* © Estate of Philip Larkin and reprinted
by permission of Faber and Faber Ltd; p.14 *Riddley
Walker* © Estate of Russell Hoban and reprinted
by permission of Bloomsbury; p.16 *Autobiography*,
© Estate of John Cowper Powys and reprinted by
permission of the Estate of John Cowper Powys;
p.19 'Little Gidding' taken from *Four Quartets* ©
Estate of T.S. Eliot and reprinted by permission of
Faber and Faber Ltd; p.21 *Ode: Intimations of
Immortality from Recollections of Early Childhood*
© Estate of William Wordsworth and reprinted by
permission of The Wordsworth Trust

Modern Art Oxford staff:
Michael Stanley, Director. Flora Cranmer-
Perrier, Operations Manager; Sara Dewsbery,
Press and Marketing Officer; Sheridan
Edward, Office Manager; Paul Teigh, Gallery
Manager; Rachel Howkins, Retail Manager;
Paul Luckraft, Curator; Sarah Mossop,
Head of Learning and Partnerships; Barbara
Naylor, Finance Administrator; Kyla Owen,
Development and Events Coordinator;
Sarah Plumb, Project Manager Learning and
Partnerships; Melanie Pocock, Inspire Fellow;
Hayley Raines, Events Duty Manager;
Helen Shilton, Head of Operations and Visitor
Services; Verity Slater, Director – Strategy
and Development; Emily Smith, Curator;
Natasha Vicars, Project Manager Offsite and
Residencies; and Caroline Winnicott,
Director – Finance and Resources.

Exhibition installation crew:
Heather Bignell, Tom Cretton, Adam Maynard,
Kay Sentance, Matt Terry, and Ben Young.

Council of Management:
David Isaac (Chair), Hussein Barma,
Jonathan Black, Jack Kirkland, Kirsty
MacDonald, Rosie Millard, Diana Parker,
Amanda Poole, and Robert Rickman.